MET KOUPE-M

YOU CAN CUT ME OFF,

RACHE-M JETE-M

UPROOT ME, TOSS ME AWAY

OU MET BOULE-M

YOU CAN ROLL ME,

CHABON AK MWEN

BURN ME TO CINDERS

O P'A' SISPANN

BUT BIRDS WON'T QUIT

AN RASIN-MWEN

NESTING IN MY ROOTS AND

LESPWA P'AP BOUKE

HOPE DOESN'T WITHER

RI NAN KE-M

BUT INSTEAD BLOSSOMS IN ME

This book is dedicated to the people of Haiti, who welcomed me into their extraordinary lives and co-created these photographs. Your bright smiles, hopeful spirits, and resilient souls made me realize what is truly important in life and inspired me to ensure that these photographs serve a higher purpose.

100% of the royalties of this book go to the following NGOs with whom I have worked in Haiti:

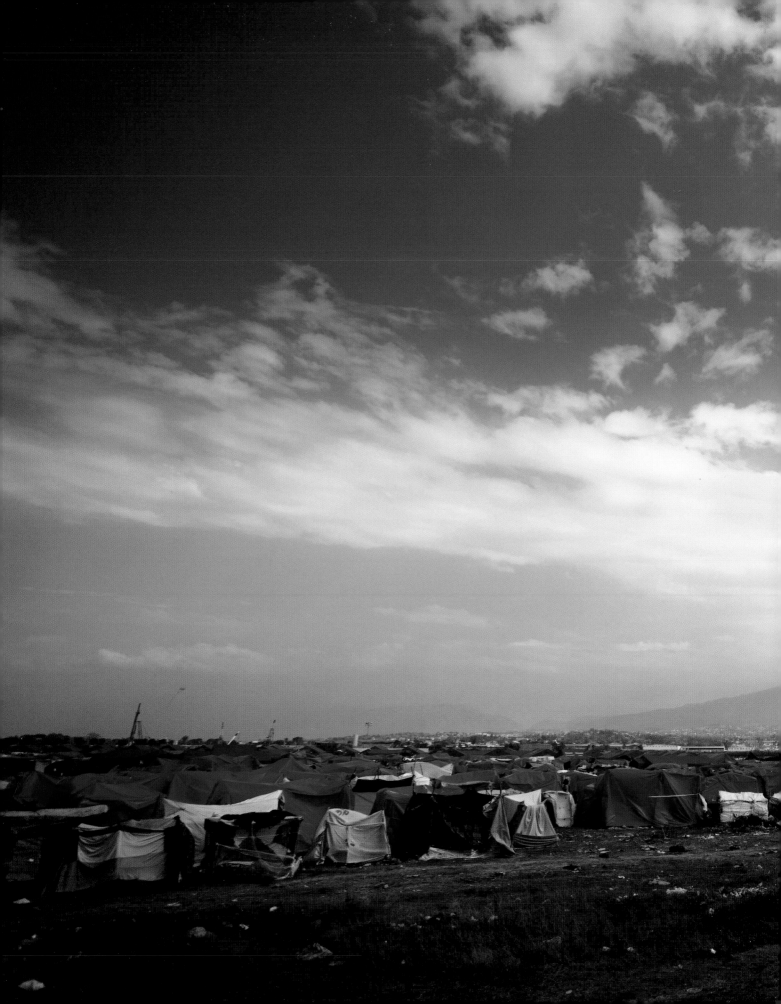

# TENT LIFE: HAITI

Photographs and Journal by Wyatt Gallery | Essay by Edwidge Danticat

Umbrage Editions

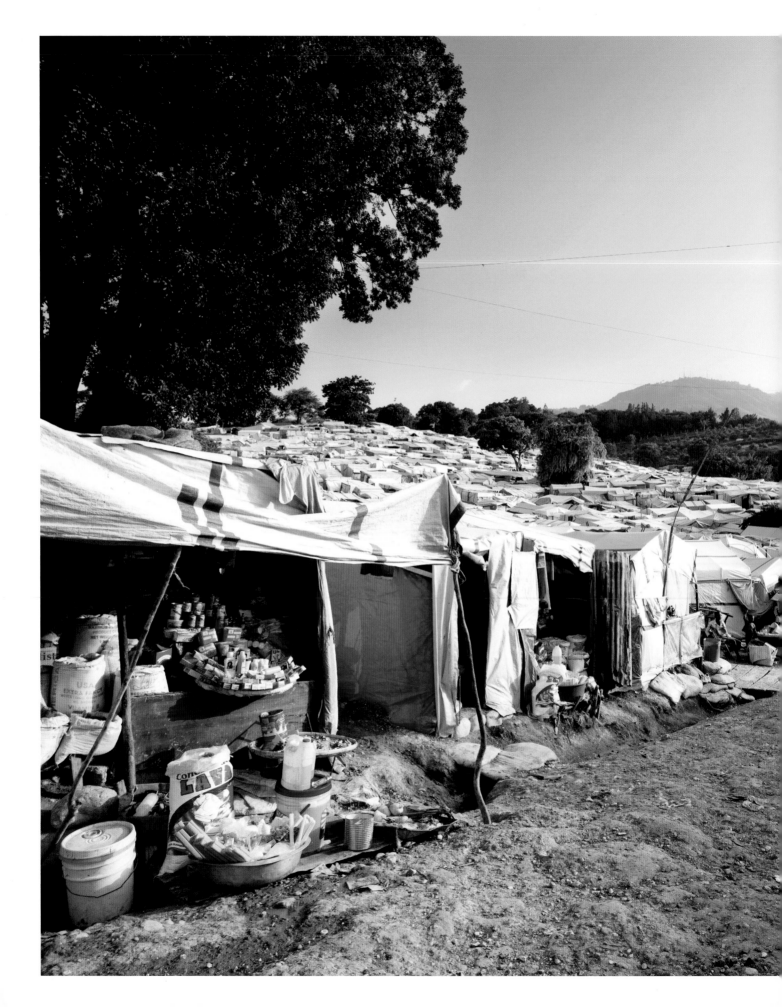

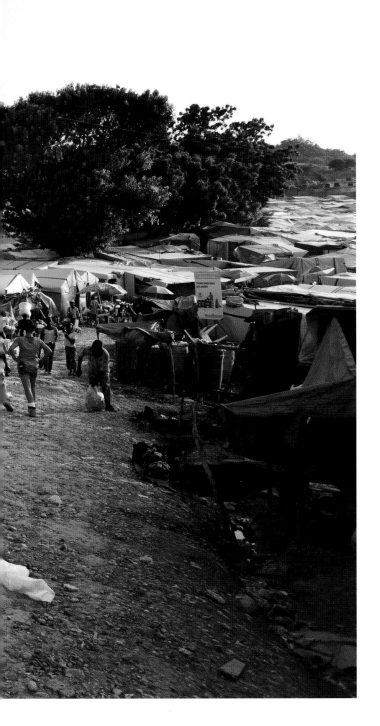

# Table of Contents

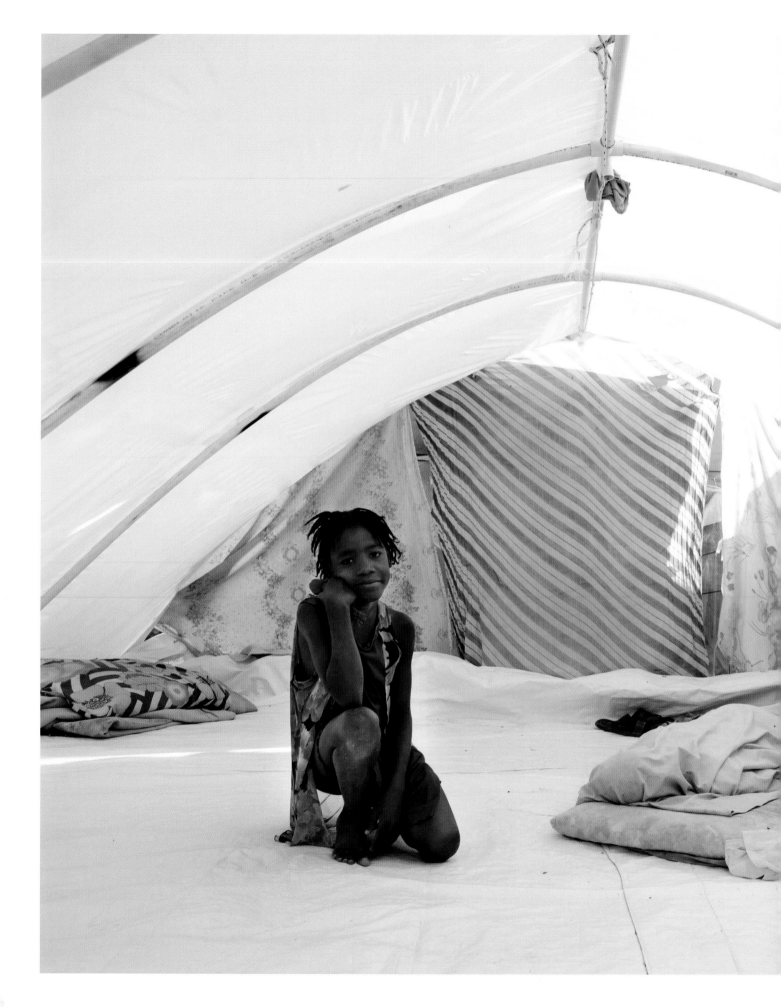

# Introduction

People often ask me:
*"How did you decide to photograph in Haiti?"*

It began in 2004, when a tsunami devastated Southeast Asia and I felt compelled to help but did not know how. One week later, my friend and fellow photographer Kareem Black and I set off to Sri Lanka with our 4x5 cameras and no clue what to expect. After ten emotionally exhausting days, I realized what I had photographed was a spirit of hope. Nine months later, another friend and photographer, Will Steacy, urged me to document the wake of Hurricane Katrina. Drained by the experience in Sri Lanka, I reluctantly joined Will to capture the aftermath of this devastating natural disaster. In New Orleans, I was drawn to the spirit of the people as seen through the remnants of their personal spaces and their belongings.

On January 12, 2010, I was on assignment in Curaçao when a 7.0 magnitude earthquake devastated Haiti, leaving over 200,000 people dead and 1.5 million homeless. Having spent over a decade photographing in the Caribbean, I felt an urgent, powerful calling to help Haiti.

On March 6, 2010, through the efforts of Kareem Black, Craig Duffney, Jeremy Carroll, Eugene Fuller, Adam Reeves, Alessandro Simonetti, and funding from BBDO advertising agency, we formed *Le Sét Collective* and traveled to Port-au-Prince, Haiti to volunteer with Healing Haiti and document the widespread devastation. Amid the people of Haiti, we discovered an intense sense of hope, resilience, and, at times, joy.

On September 20, 2010, I returned to Haiti to continue photographing the heartbreaking living situations within the massive tent cities turned makeshift shantytowns. Although the situation had barely improved, the people of Haiti continued to embody an immeasurable spirit of strength, hope, and resilience, as is evident in these photographs.

– Wyatt Gallery

I was first introduced to "tent life" by my second cousin, Jesula. Before the January 12, 2010 earthquake, Jesula had been living with her mother and younger sister in a rented two-room house at the bottom of a slippery hill in Bel Air, a poor neighborhood in Port-au-Prince, where I also grew up. Jesula's dad and my dad—who'd both died before the earthquake—were first cousins.

Even though she was in her early twenties, Jesula's primary means of financial support were relatives abroad and her mother, who sold pens, notebooks, Bibles, and hymn books in downtown Port-au-Prince. Jesula had completed her studies, but had no job prospects.

On the day of the earthquake, both the walls of her rented house and the downtown wall that shielded Jesula's mother from the sun collapsed. Part of the downtown wall pinned Jesula's mother to the street and she might have died there had Jesula and her sister not found her. From all obvious signs—her inability to move her legs or stand—it seemed that Jesula's mother's back was broken and during the days following the earthquake, Jesula and her sister loaded and unloaded their mother on and off the back of several mototaxis and pickup trucks to bring her to three field hospitals to get her back X-rayed. Finally, when Jesula's mother's back was X-rayed in an Israeli field hospital, it was discovered that she had not severed her spine or broken any bones. She still couldn't walk, but patients with life-threatening injuries needed her bed—so she was sent home.

Except there was no home.

Jesula and her sister took their mother to Champs de Mars Plaza, across from the shattered National Palace, where a new tent city was emerging. In those very early days, when there were still no tents or tarps, when people were just erecting lean-tos with sticks and bedsheets, whenever I would call Jesula on her cell phone or she would call me on my house phone

in Miami, I would ask, "How are you?" She would answer, "*Nou la, an chè e an òs,*" "We're here, in flesh and bone," her favorite expression.

The fact that people were living outside, would be living outside for a long time, still seemed unimaginable to me and I would always expect a different answer when I would ask, "Where exactly are you?" But she would always answer, "*Sou Champs de Mars la,*" "On Champs de Mars Plaza." "You know we're not used to living like this," she would add. "People on top of other people. We're not used to it."

Another relative, my aunt Zi, took to calling sleeping in the golf club near her damaged house, "being in the desert," like the wandering ancient Israelis after they had crossed the Red Sea.

A few days later, some relatives from the countryside came and took Jesula's mother to Les Cayes. The house there, which was meant for about eight people, now held thirty. In the meantime, Jesula kept looking for a place to rent in Port-au-Prince, an impossible task in a city where those few remaining habitable houses were priced beyond the reach of most Haitians. At night, Jesula and her sister could not bring themselves to fall asleep in the tent city on Champs de Mars, she told me, for fear of being raped.

The first time I went to see Jesula, we met across from the now massive tent city next to a wall covered with bootleg movies for sale. While I was waiting for Jesula in the span of just a few minutes, several people walked by, talking to themselves while tugging at their hair or staring at the floor. They were *nouvo fou* people said, folks who had been rendered mad by the earthquake. Jesula emerged from one of the many narrow corridors of the tent city and said, "Come see where I am."

I followed her down some cramped alleys in between structures of all kinds. It was a small city, within a city,

# In Flesh and Bone by Edwidge Danticat

within a city. Many of the structures were now semi-permanent-looking wood and corrugated metal shacks, but there were still bedsheet and tarp-covered lean-tos and more than a few tents, some meant for one person to take on a weekend camping trip, but now housing several people, including small children. In between mothers bathed their fidgety toddlers or cooked on small metal charcoal stoves. Young women braided each other's hair. A skinny dog limped ahead of us and even as she shooed him away, Jesula knew its name and who it belonged to.

Her tent was a red single sleeper, but she slept in it with her sister, who was sitting on a grey wool disaster blanket in front of it, and even with high decibel conversations and passing traffic, was listening to music from a small transistor radio while painting her fingernails. Jesula introduced me to her neighbors in the next tent, a family of four, whose dark green tent was only slightly larger than her and her sister's. On the inside walls of Jesula's red tent were family pictures: pictures of her mother and father, herself, and her sister, some of which she had been carrying around and others that had been plucked from the rubble of her house. She invited me inside and I squeezed in between the zippered flap and a small overnight bag on which she had placed a lock—as if one could not easily walk away with the whole thing.

"I need to move," she said.

And a few days later, another cousin with a structurally sound house in Port-au-Prince took her and her sister in.

Unfortunately, not everyone has exited tent life as quickly as Jesula. And even those who leave have no guarantee that they might not return. With only a small percentage of the earthquake rubble having been removed, it will take a very long time for the more than one and a half million people who are living in tent cities to return to permanent housing. However, it is extremely inspiring to see—as in these photographs—how people have tried to make a nearly impossible life bearable. They gather the few belongings they have left and organize them as neatly as possible. They structure themselves in committees. They resist forced evacuations. They form security brigades and clean up crews. They clean the perimeters of their tents, engaging in an active battle against trash. They cover the outside of their tents with sketches and drawings. They plan soccer games and sing-alongs for children who can't afford to go to school. They start beauty parlors and barber shops, wear immaculately washed and ironed clothes—as if to stand out even more against the disorder and chaos around them.

Tent life is not to be idealized though. It is indeed about misery and pain. It is about standing up when it's raining because the floor where you are sleeping becomes a pile of mud. It is about lightning strikes that kill babies, fires that catch on all-too-quickly. It is about extreme vulnerability for women and girls, all-too-common rapes. It is about lack of privacy, jobs, food, clean water, sanitation, and waste disposal. It's about the grave menace of spreading cholera and other infectious diseases. But it is also about what Haiti has always offered: spontaneous and lasting community as well as cooperation. It is about people looking after one another in extremely difficult times, sharing what very little they have. It is about love, dignity, resilience, and, yes, hope.

"*Pito nou lèd, nou la,*" says the Haitian proverb. "Better that we are ugly, but we are here." Tent life is a daily struggle against ugliness, both psychological and physical. It is an undeniable affirmation that people have survived against all odds and that they are still here. *An chè e an òs*, "in flesh and bone," as my cousin Jesula likes to say. But also in heart and spirit, in our hearts and in our spirit.

November 2010

**1492:** Christopher Columbus lands and names the island Hispaniola, or "Little Spain."

**1496:** The Spanish establish the first European settlement in the western hemisphere at Santo Domingo, now capital of the Dominican Republic.

**1697:** Spain cedes the western part of Hispaniola to France, and this becomes Saint-Domingue.

**1801:** A former black slave who became a guerrilla leader, Toussaint L'Ouverture, conquers Haiti, abolishing slavery and proclaiming himself governor-general of an autonomous government over all Hispaniola.

**1802:** A French force, led by Napoleon's brother-in-law, Charles Leclerc, forces L'Ouverture into an honorable surrender and subsequent retirement.

**1804:** Saint-Domingue becomes independent; Governor-General, and former slave, Jean-Jacques Dessalines declares himself emperor and renames the colony Haiti, or "Land of Mountains."

**1806:** Dessalines is assassinated and Haiti is divided into a black-controlled north and a mulatto-ruled south.

**1820:** Jean-Pierre Boyer, a mulatto and former compatriot of Toussaint L'Ouverture, unifies Haiti, but excludes blacks from power. After Santo Domingo becomes independent in 1821, he conquers it, ruling the whole of Hispaniola until his ousting in 1843.

**1915:** The United States invades Haiti following black-mulatto friction, thought to endanger U.S. investments in the country. It dismantles the constitutional system and takes over.

**1934:** After establishing a National Guard system to run the country, U.S. Marines withdraw. The U.S. retains influence in Haiti's financial affairs until 1947.

**1957:** Voodoo physician François "Papa Doc" Duvalier is elected president after former military coup leader General Paul Magloire resigns in December 1956, leaving the country in disarray. Duvalier establishes a new constitution, seeing off an attempted military coup in 1958.

**1961:** Duvalier begins to violate the 1957 constitution, calling for an election and being reelected unopposed despite a constitutional clause prohibiting reelection. In 1964, after a rigged constitutional referendum (with all ballots premarked "Yes"), he declares himself "President for Life."

**1971:** Duvalier dies and is succeeded by his nineteen-year old son, Jean-Claude, or "Baby Doc," who also declares himself President for Life.

**1986:** Baby Doc flees Haiti in the wake of mounting popular discontent and is replaced by Lieutenant-General Henri Namphy as head of a governing council.

**1988:** Leslie Manigat becomes president, but is ousted in a coup led by Henri Namphy, after Namphy had been dismissed from the military by Manigat. Brigadier-General Prosper Avril subsequently overthrows Namphy.

**1990:** After protests force Avril into exile, a series of provisional governments rule until Jean-Bertrand Aristide is elected president in Haiti's first free and peaceful polls.

**1991:** Aristide is ousted in a coup led by Brigadier-General Raoul Cédras, triggering sanctions by the U.S. and the Organization of American States.

**1994:** The military regime relinquishes power in the face of an imminent UN-sanctioned U.S. military invasion. The U.S. forces oversee a transition to a civilian government with Aristide continuing his interrupted presidency.

**1995:** United Nations peacekeepers begin to replace U.S. troops. René Préval is elected president in December.

**1999:** After serious political deadlock, including a number of disagreements with his deputies, Préval rules that parliament's term has expired and begins ruling by decree.

**2000:** In November, Aristide is elected president for a second term.

**2001:** In December, thirty armed men try to seize the National Palace in an apparent coup attempt; twelve are killed in the raid, which the government blames on former army members.

**2002:** Haiti is approved as a full member of the Caribbean Community (CARICOM) trade bloc.

**2003:** Voodoo recognized as a religion, on a par with other faiths.

**2004:** Early in the year, celebrations marking 200 years of independence turn into an uprising against President Aristide, who is forced into exile. An interim government takes over.

By late spring, severe floods in the south of Haiti and parts of the neighboring Dominican Republic leave more than 2,000 dead or missing. Over 3,000 more are killed or left missing later in the season when the north is flooded as a result of several hurricanes. UN peacekeepers arrive to help flood survivors, and international donors pledge more than US$1billion in aid.

Levels of deadly political and gang violence rise in the capital, Port-au-Prince, with armed gangs loyal to former president Aristide said to be responsible for many killings.

**2005:** Ravix Remissainthe, prominent rebel leader and a key figure in the uprising that led to Aristide's ousting, is killed by police in April. In July, Hurricane Dennis kills at least forty-five people.

**2006:** In the first elections since Aristide was overthrown, René Préval is again elected president after a deal is reached over spoiled ballot papers. The democratically elected government takes office in June, led by Prime Minister Jacques-Édouard Alexis. The U.S. lifts an arms embargo, imposed in 1991, after a UN-run scheme is founded to disarm gang members in exchange for grants and job training.

**2007:** In February, UN troops launch a tough new offensive against armed gangs in Cité Soleil, one of Port-au-Prince's largest and most violent shantytowns.

**2008:** Food riots follow a government announcement to cut the price of rice in a bid to halt unrest. Parliament dismisses Prime Minister Alexis, with Michèle Pierre-Louis succeeding him. The U.S. and World Bank announce extra food aid totaling US$30million. In response to a plea from President Préval for more police to help combat a wave of kidnappings-for-ransom, Brazil agrees to boost its peacekeeping force.

By fall, nearly 800 people are killed and hundreds left injured as Haiti is hit by a series of devastating storms and hurricanes. In November, a school in Port-au-Prince collapses with around 500 pupils and teachers inside. The authorities blame poor construction methods, and the tragedy becomes a symbol for the rampant corruption in the government.

**2009:** Former U.S. President Bill Clinton is appointed UN Special Envoy to Haiti, and the World Bank and International Monetary Fund cancel 80 percent (US$1.2billion) of Haiti's debt, after judging it to have fulfilled economic reform and poverty reduction conditions.

In October, Jean-Max Bellerive becomes prime minister after the senate passes a censure motion against Michèle Pierre-Louis.

**2010:** January 12. Over 200,000 people are killed when a magnitude 7.0 earthquake hits the capital Port-au-Prince and its wider region—the worst in Haiti in 200 years. International donors pledge US$5.3billion for post-quake reconstruction.

Red Tent Interior, Delmas 31

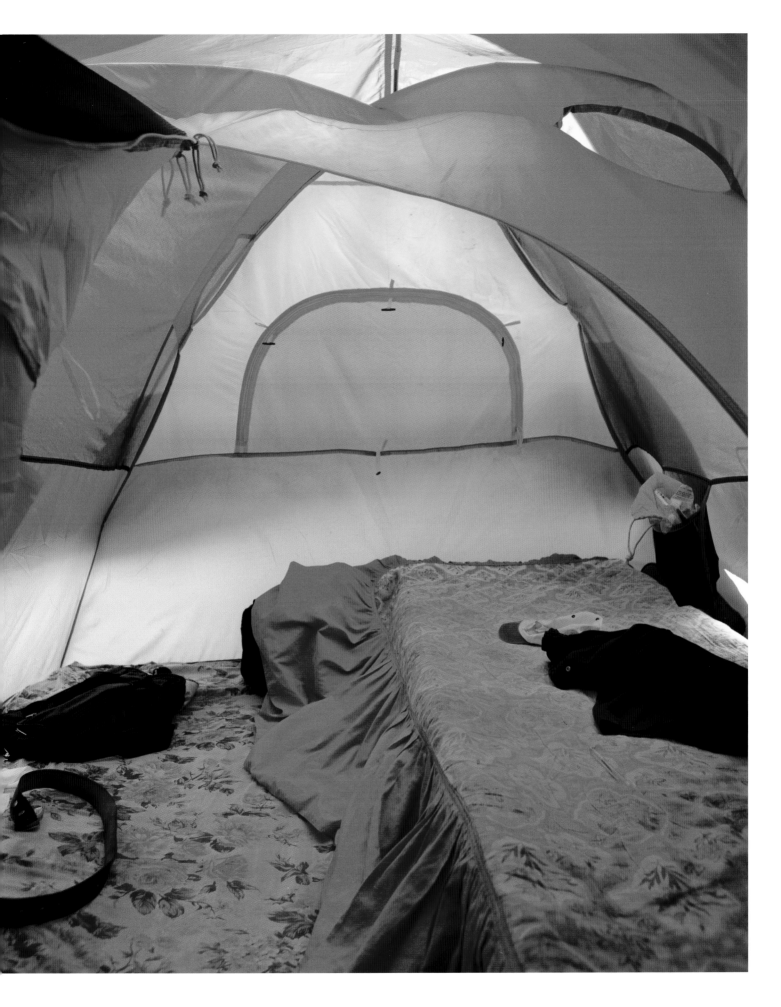

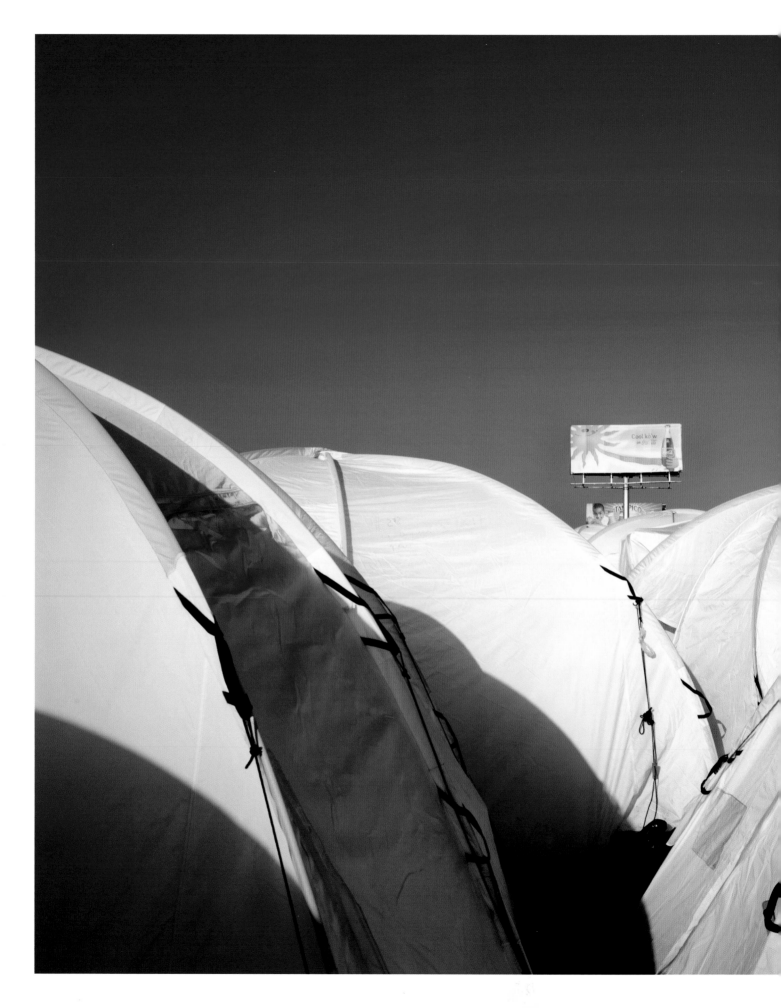

Cool Your Body with Coca Cola, Airport Camp

March 9, 2010

*Today we joined up with one of Healing Haiti's water trucks.*
*As we arrived at our first stop to give out water, there was already*
*a long line of women and children waiting patiently with their*
*buckets in the hot afternoon sun. Thousands of people depend on*
*these daily deliveries, as there is no running water and no clean*
*water whatsoever in this area of Cité Soleil.*

**Elderly Woman Waiting for Water, Cité Soleil**

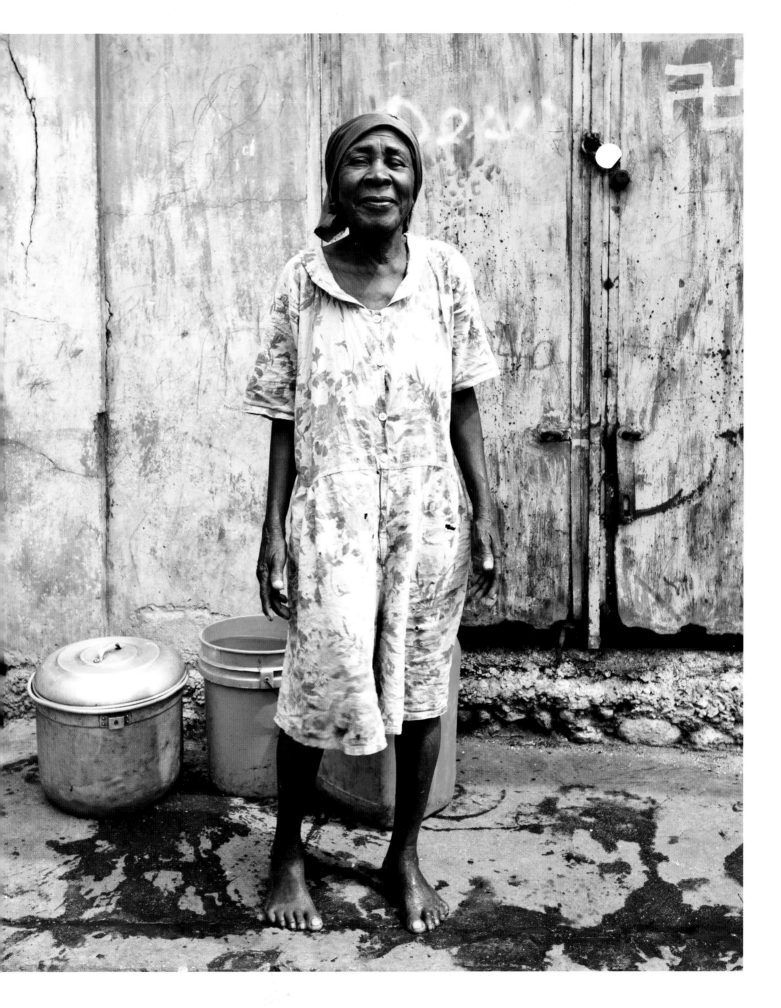

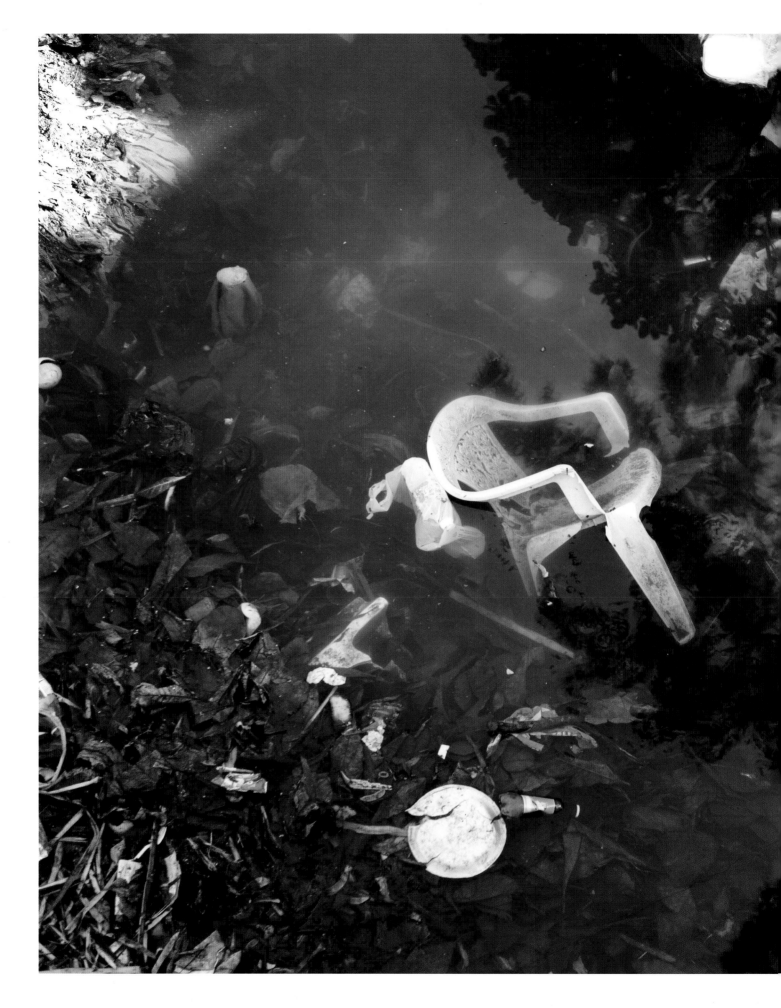

Plastic Chair in Water Canal, Delmas 31

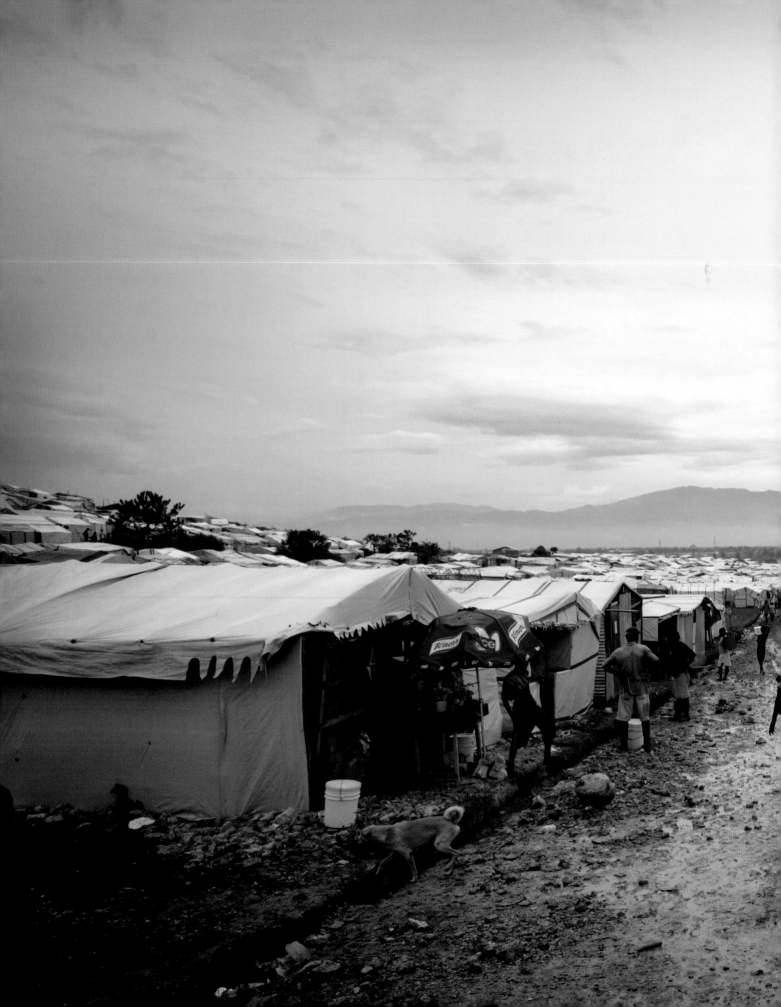

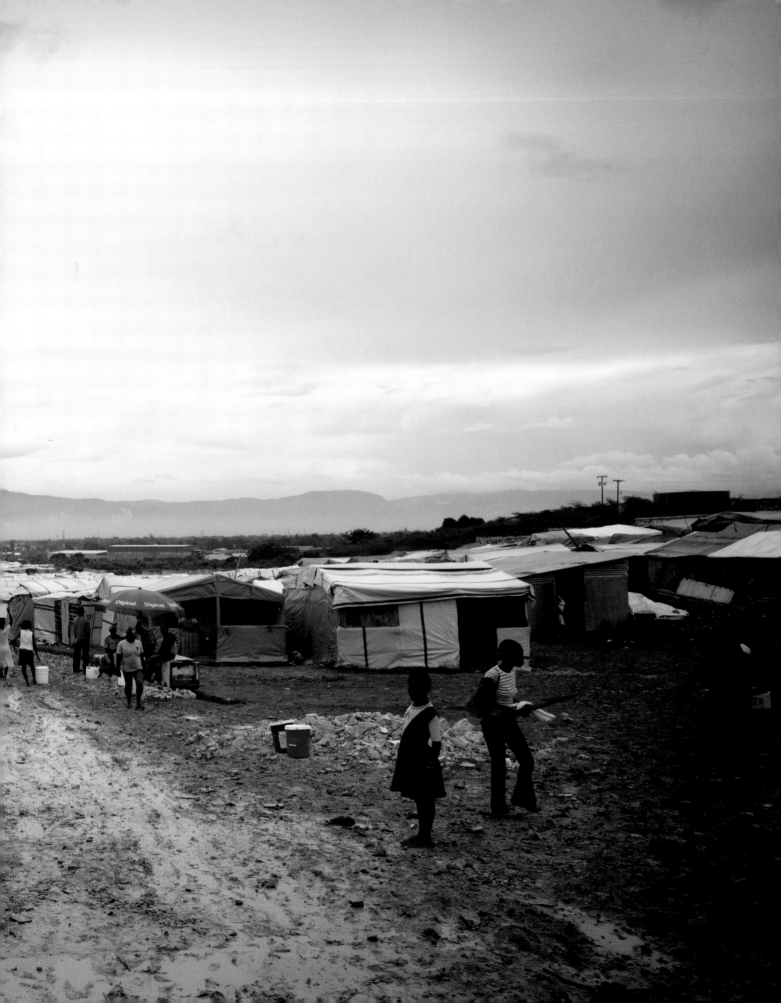

Carrying Water Through the Mud, Tabarre 52 (previous page)

Sisters in their Tent, Bobby Duval's Soccer Field

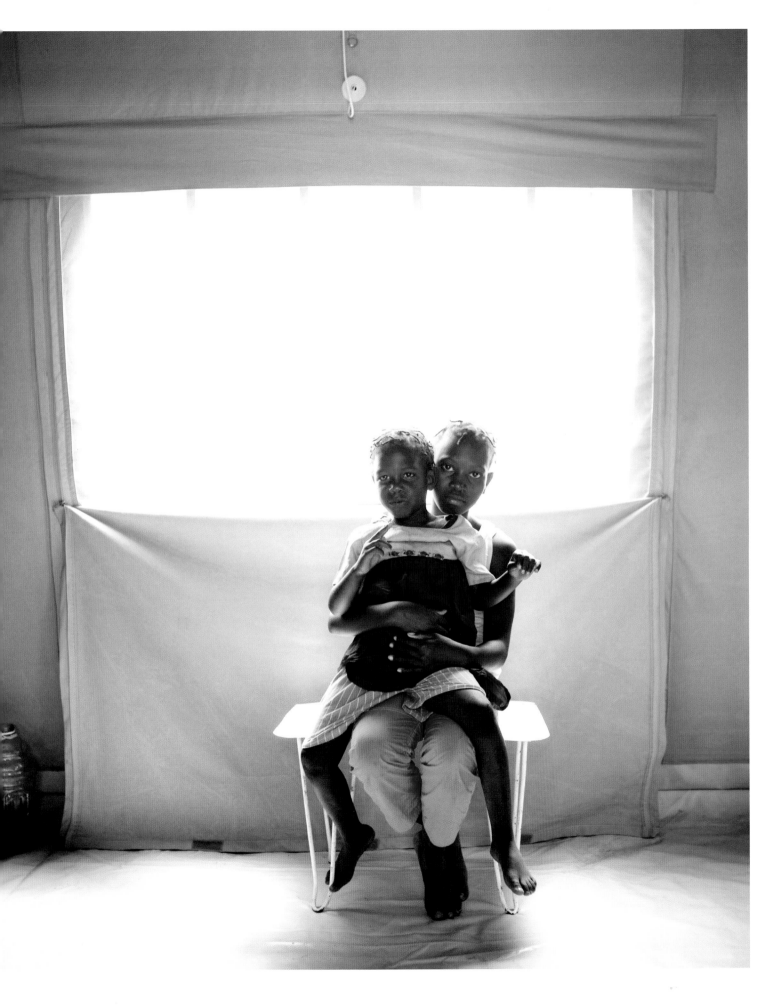

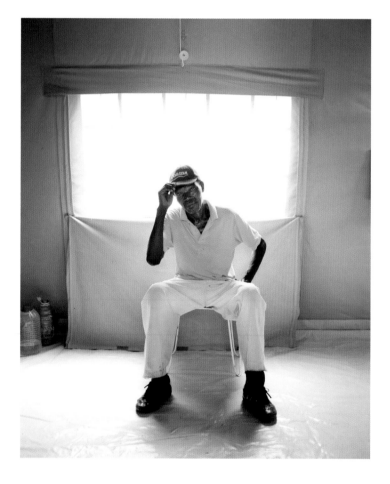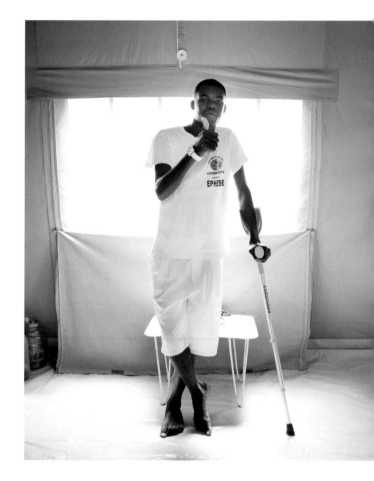

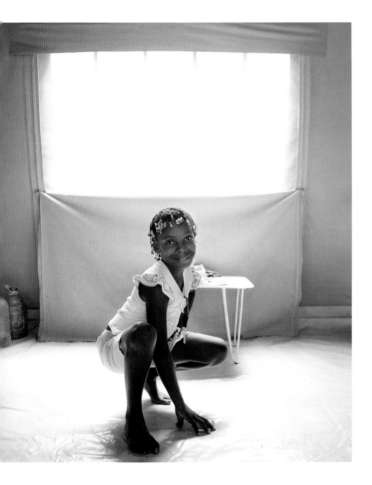
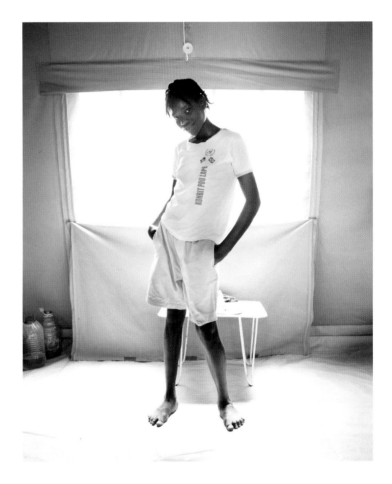

Tent Photo Booth, Bobby Duval's Soccer Field

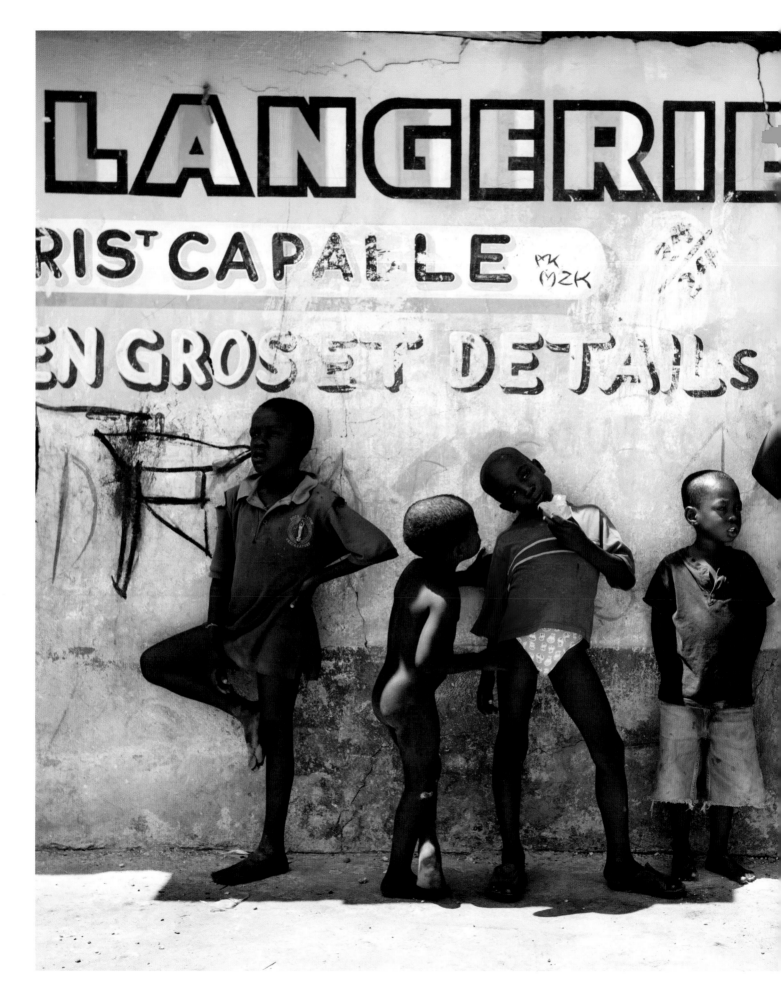

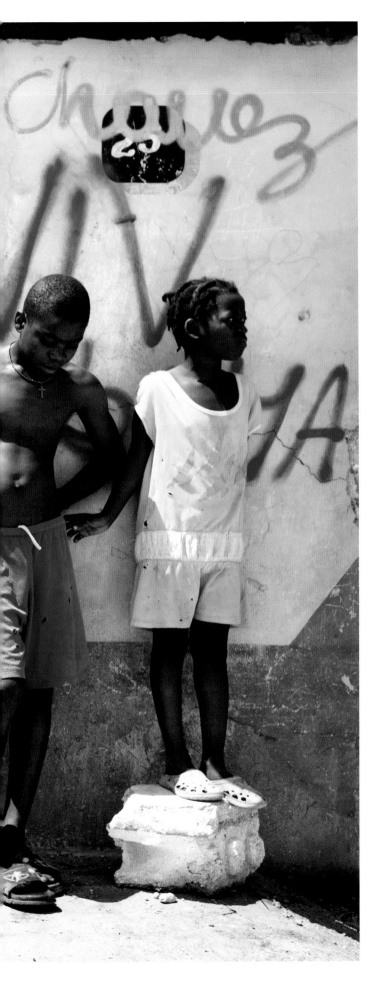

March 9, 2010

*As we pumped bucket after bucket of water, people began to cut the line in desperation. In the midst of the mayhem, I happened to turn around to see a line of children escaping from the hot sun. Behind them was written "Viv Obama," which I noticed throughout the city.*

Viv Obama, Cité Soleil

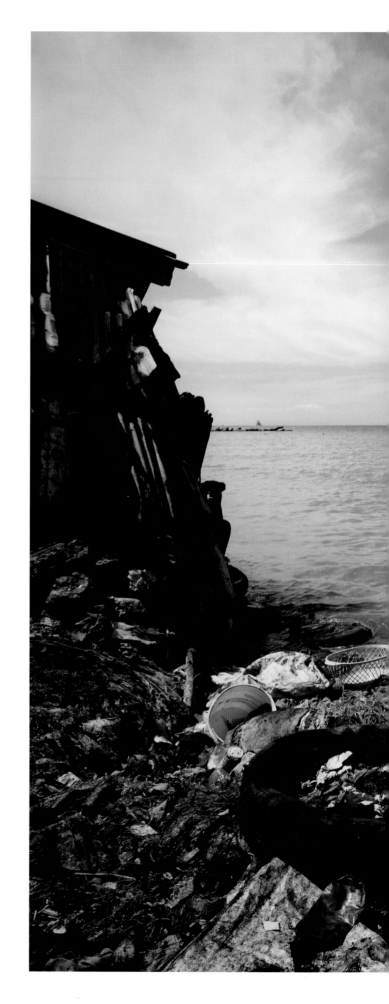

March 9, 2010

*My colleague Alessandro and I followed the truck driver down a tight alleyway to one of the neighborhoods on the ocean. Boys were swimming naked and playing in the tranquil blue sea offshore from the trash-covered beaches. The neighborhood was a maze of rusty galvanized iron walls that formed the exterior of the many homes. The boys screamed "Hey you!" at us like all others we encountered. We learned that it basically translates to: "Give me…" chocolate, food, candy, money, attention, a smile, anything, but in essence… love.*

Boys Swimming, Cité Soleil

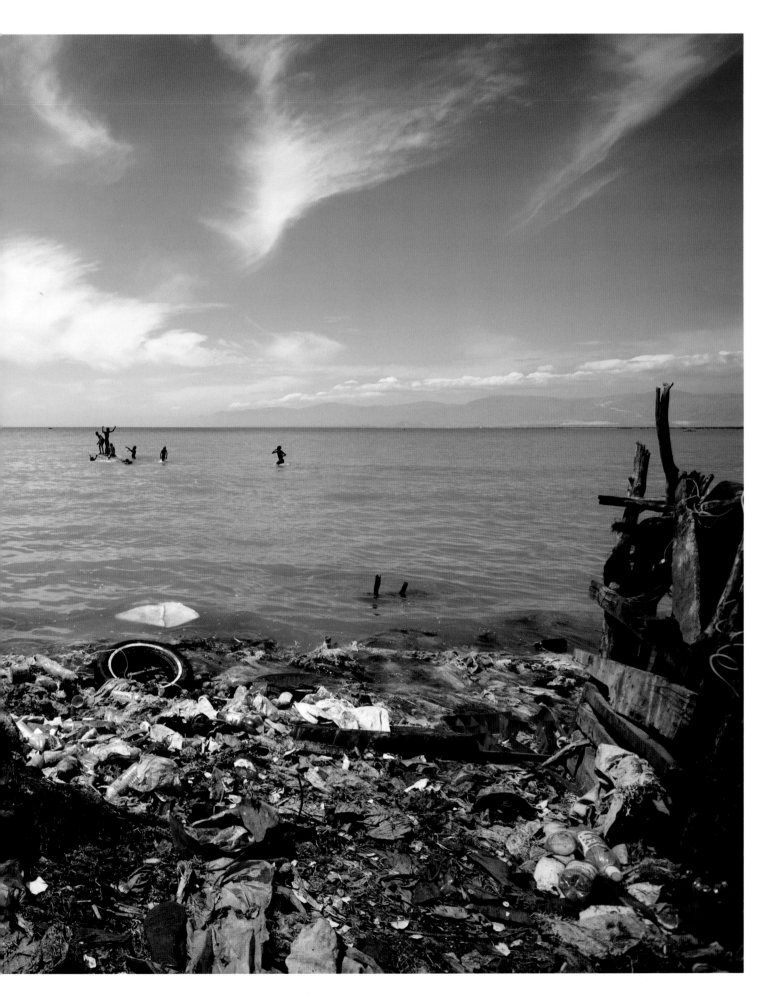

Boy Waiting for Water, Cité Soleil

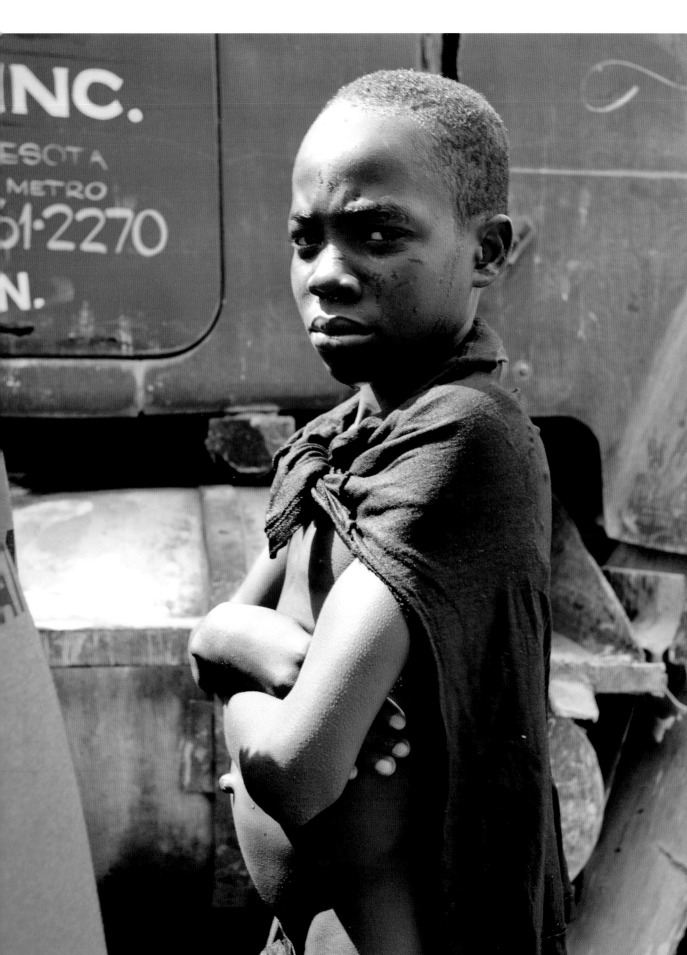

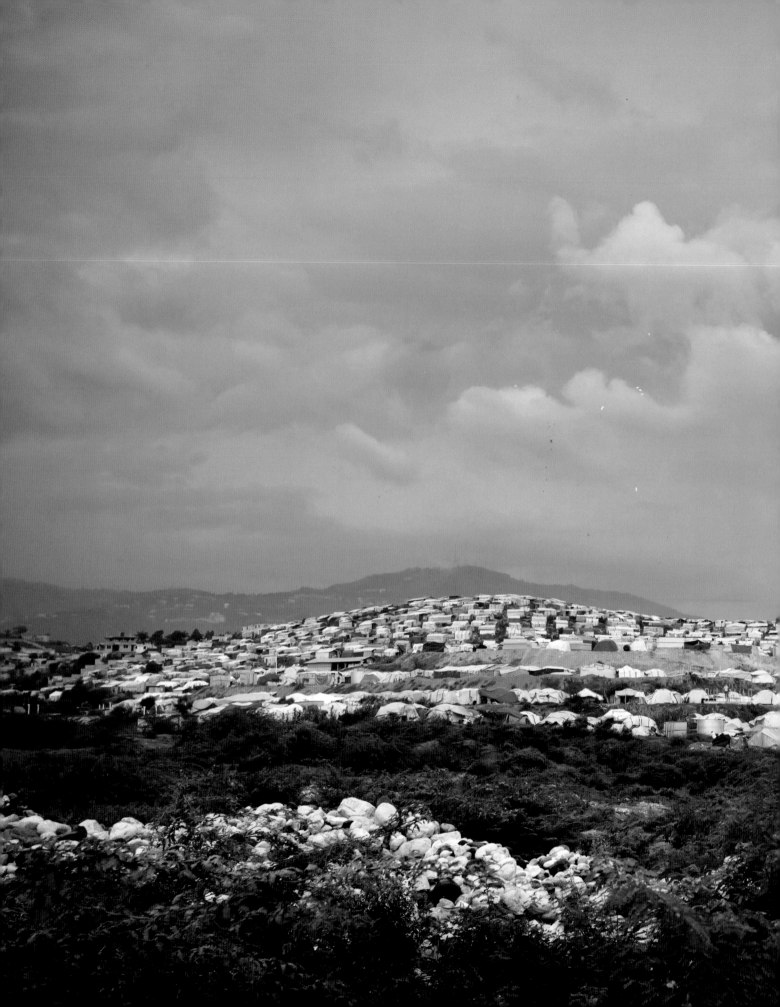

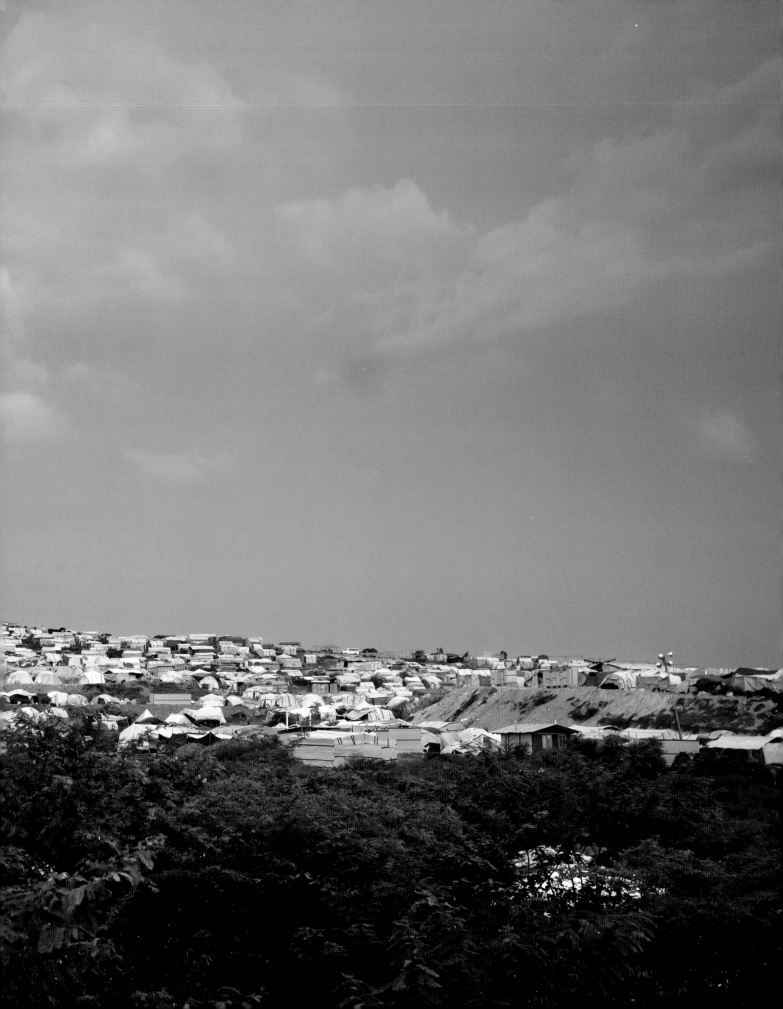

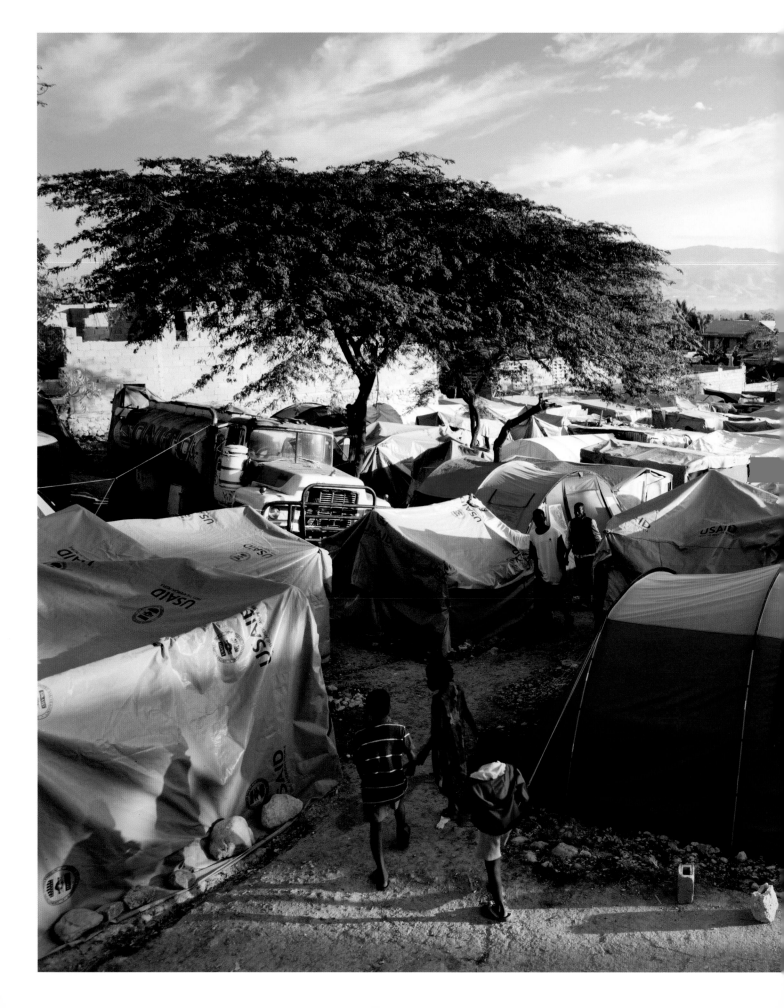

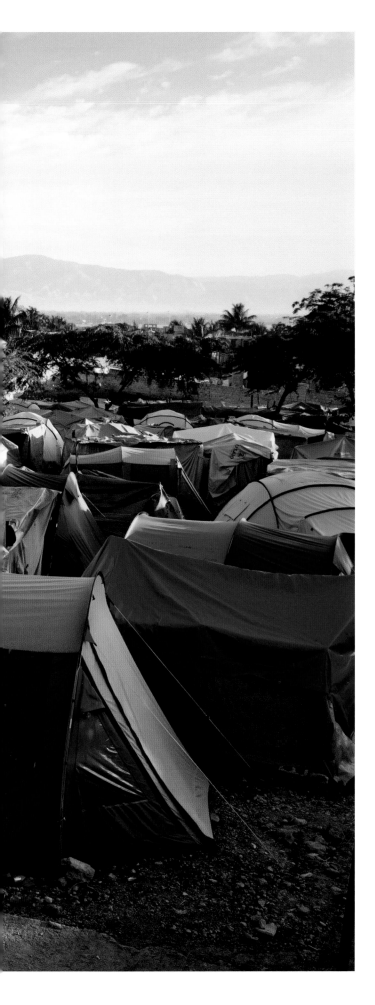

Sprawling Camp, Tabarre 52 (previous page)

Sunrise over Tents, Delmas 31

Esmerelda, Delmas 31

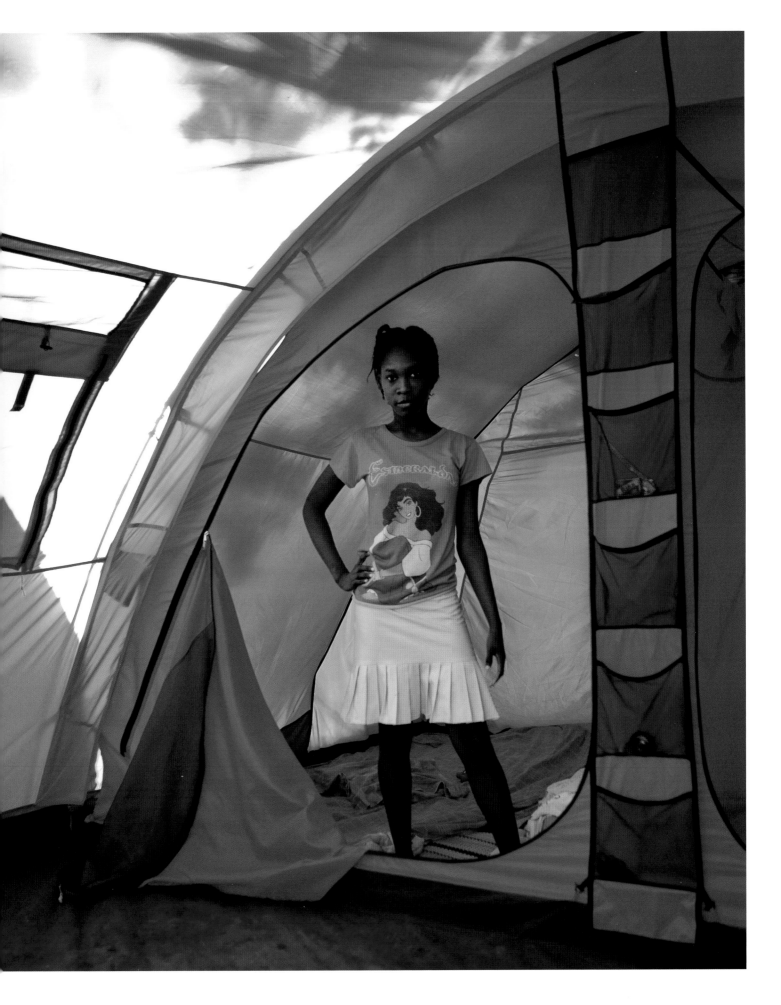

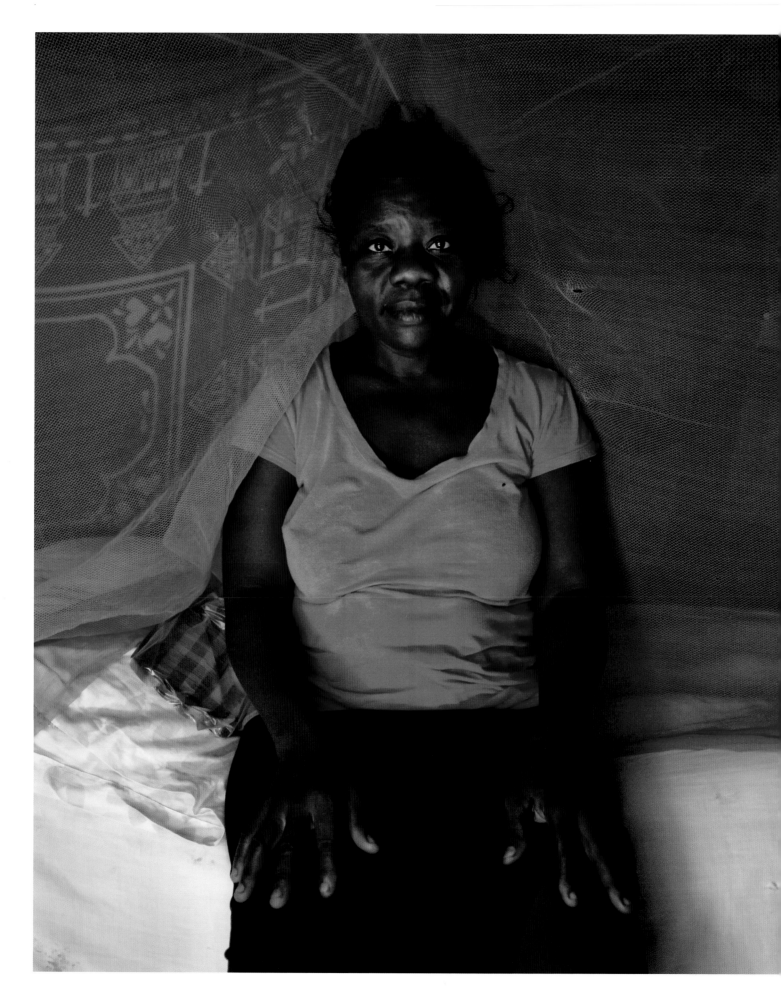

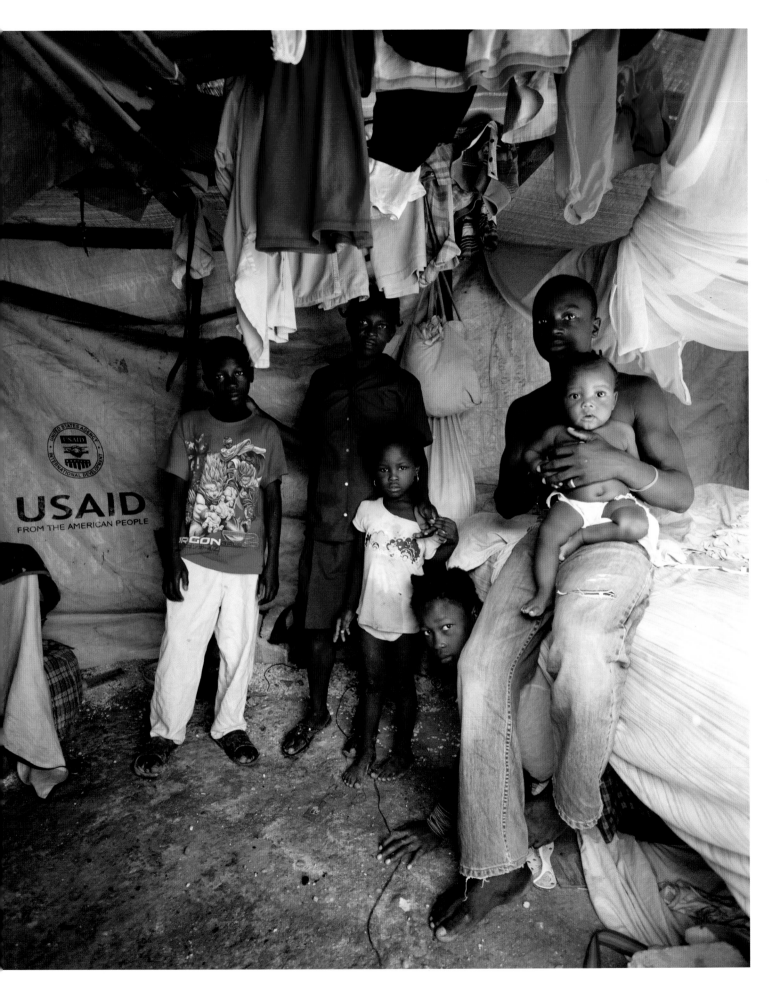

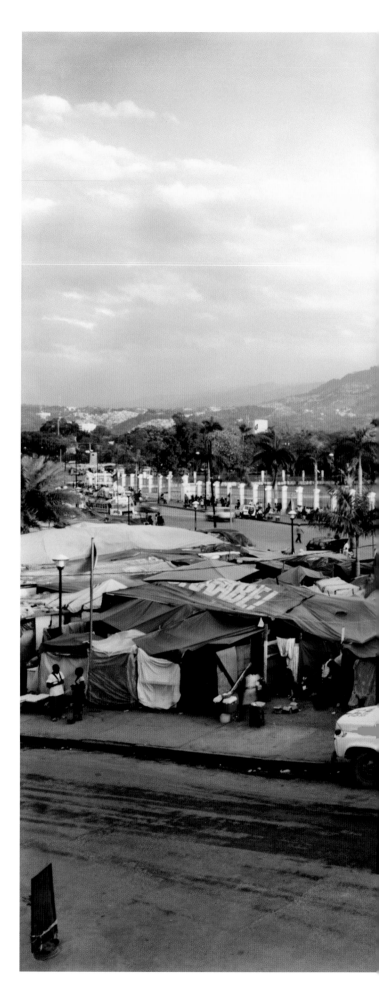

## March 8, 2010

*At the edges of the sprawling tent city Champ de Mars, groups of children were bathing, washing clothes, and urinating all within five feet of me while I photographed the remains of the crumbled National Palace. This seems typical of tent life.*

**Portraits in Shacks, Delmas 31 (previous page)**

**National Palace and Shacks**

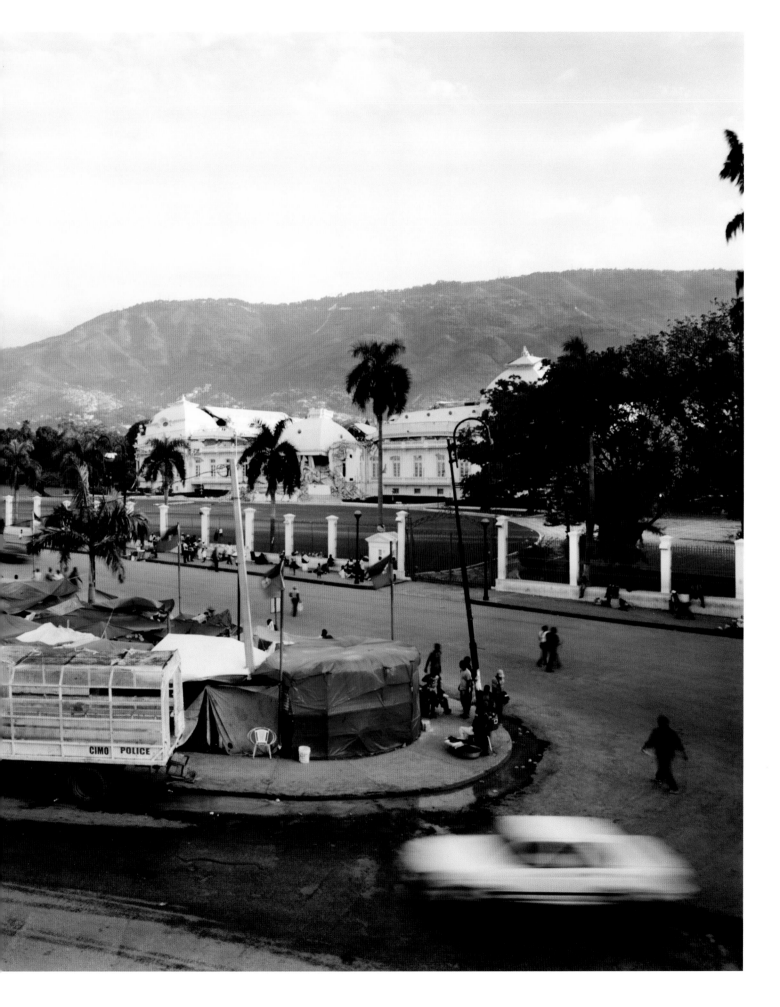

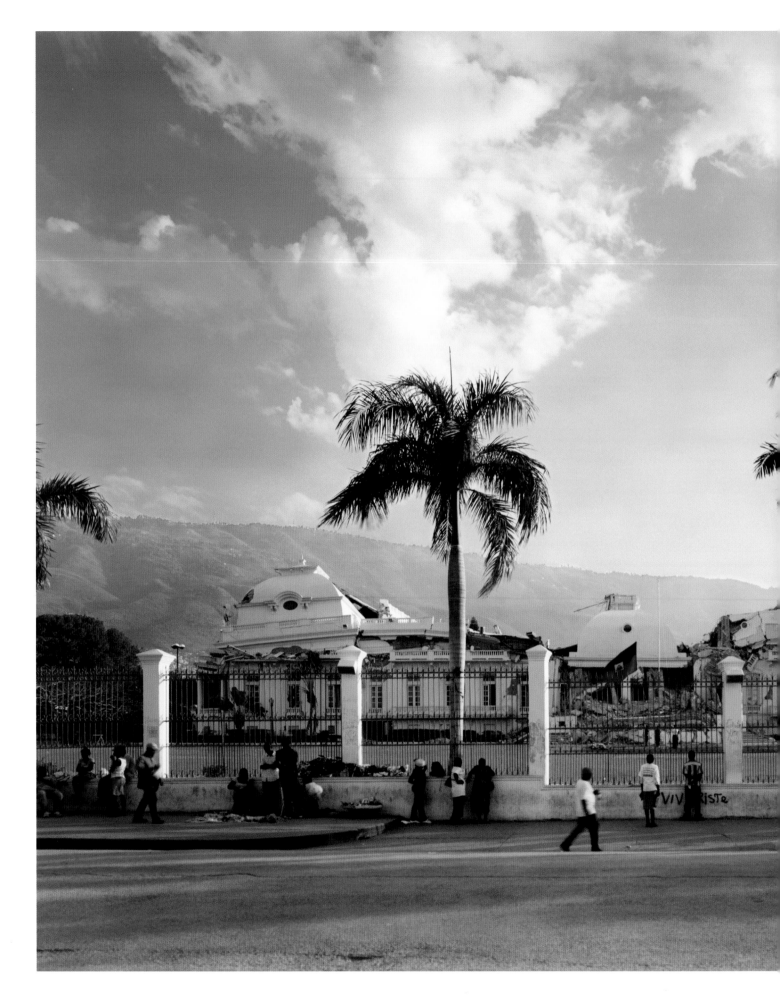

Mourning the National Palace,
Downtown Port-au-Prince

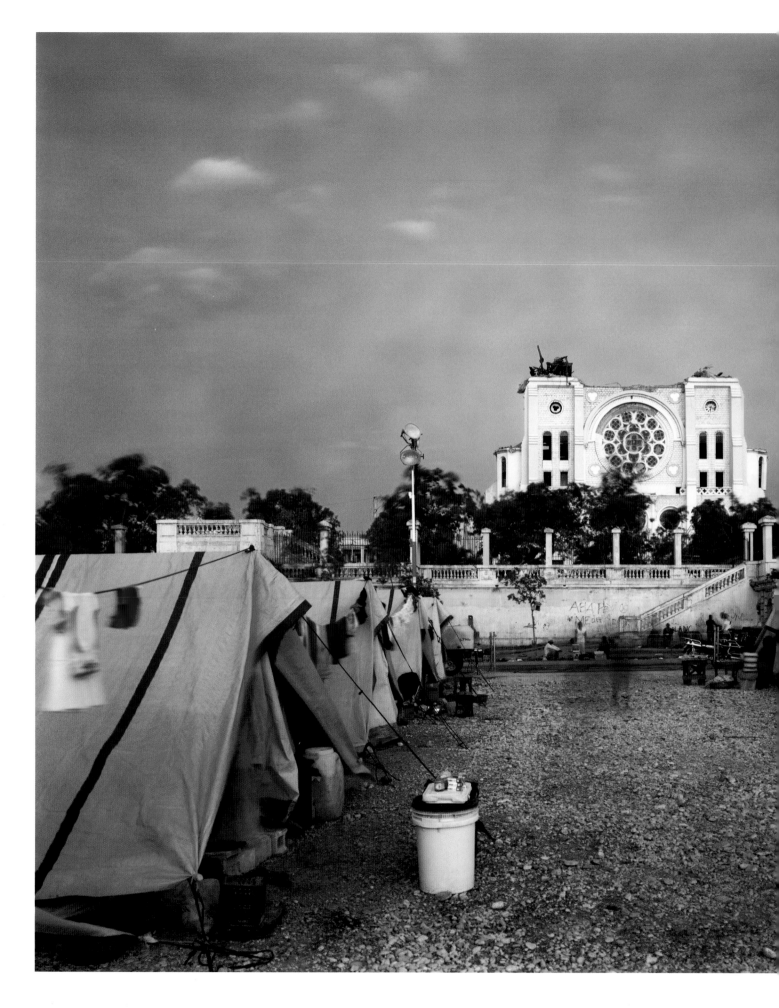

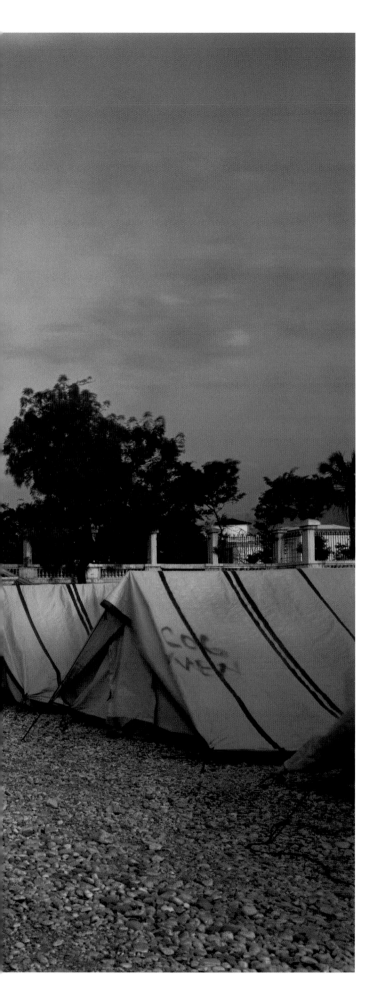

March 8, 2010

*We drove through the disaster-struck streets of downtown Port-au-Prince over to the Cathedral of Our Lady of the Assumption. It was dusk by the time we arrived and I quickly began photographing the remnants of the majestic structure as seen from a small but extremely organized tent city across the street. It seemed to glow against the darkening blue sky, due to the security floodlights coming from this small, tented world. None of us spoke as we departed the cathedral. All we could see were flickers of candlelight within the encapsulating darkness of the dusty, bumpy, and haunting drive through a destroyed Port-au-Prince.*

Cathedral in Ruins, Downtown Port-au-Prince

March 9, 2010

*We returned to the cathedral this morning. It was devastated, yet so serene compared to the rest of Port-au-Prince. The light was soft and warm. I felt like I was shooting a modern-day Roman ruin. It must have been a very beautiful church. I took my time photographing the interior while people wandered through the crumbled ruins searching for anything they could find to help them survive.*

**Cathedral of the Lady of the Assumption, Downtown Port-au-Prince**

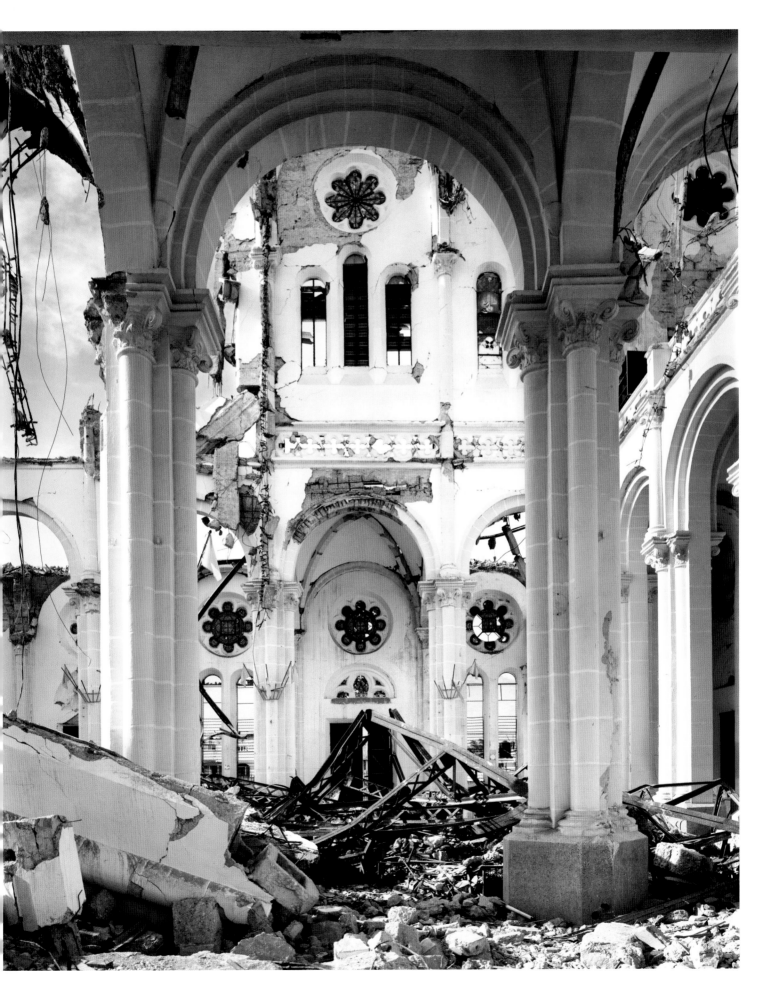

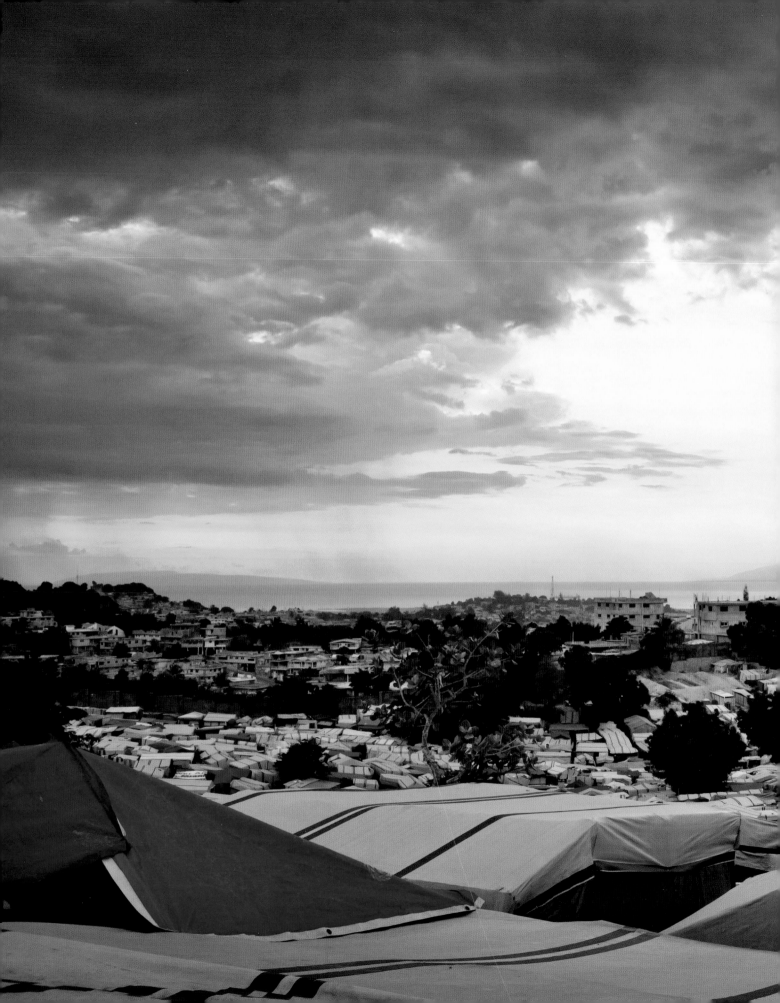

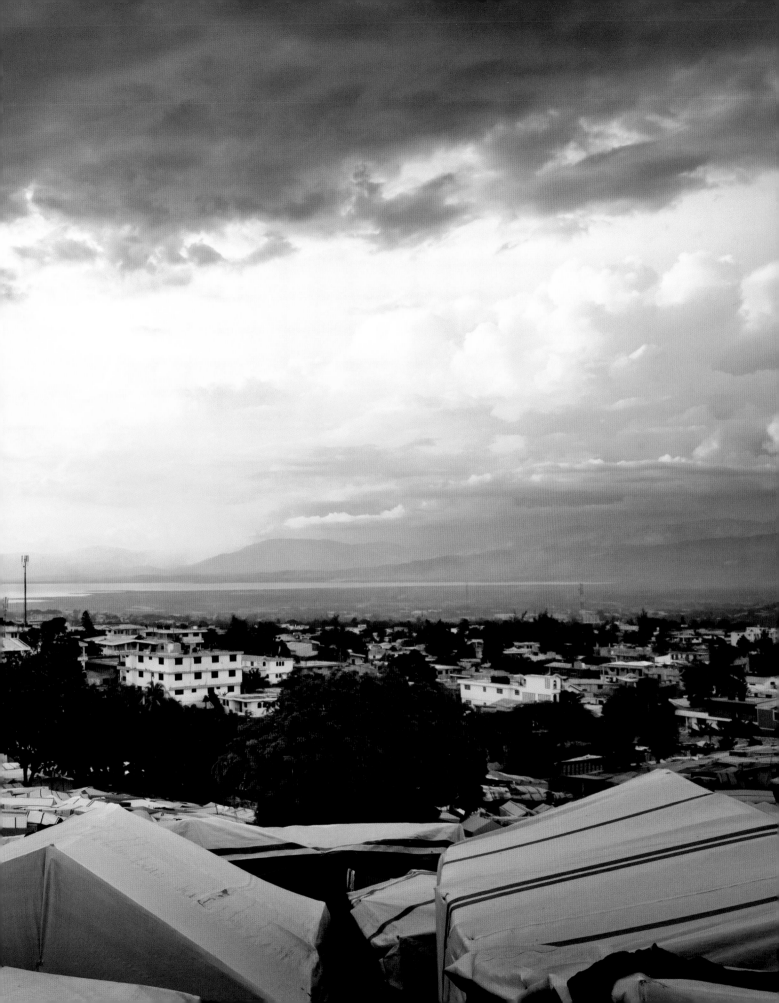

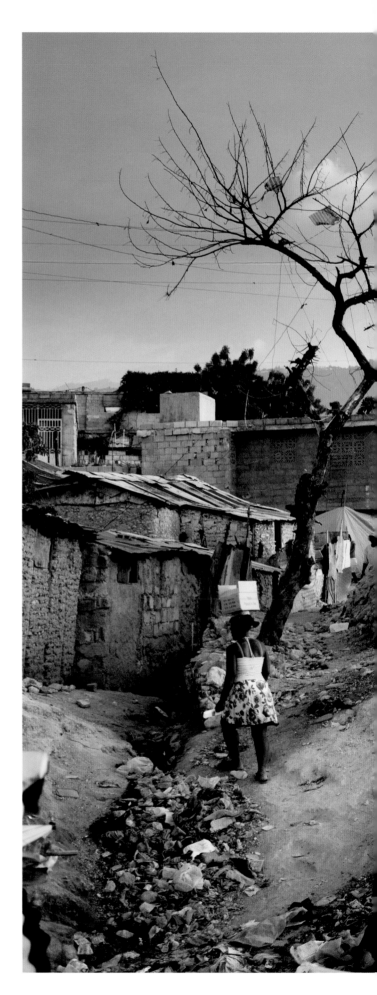

September 23, 2010

*As the sun set behind one of the hills, I came upon a mound of trash surrounded by shacks. There were goats scavenging in the trash while children played all around. It's crazy how it all seemed so normal to everyone.*

Sunset over Port-au-Prince, Pétionville Camp
(previous page)

Trash Mound, Delmas 32

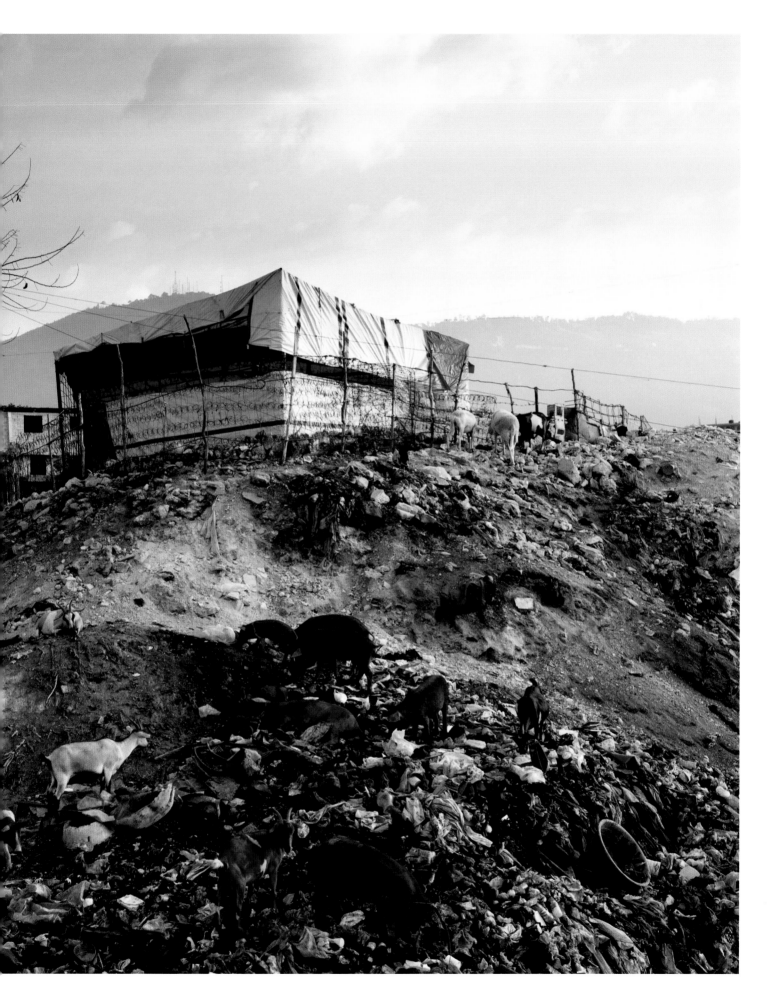

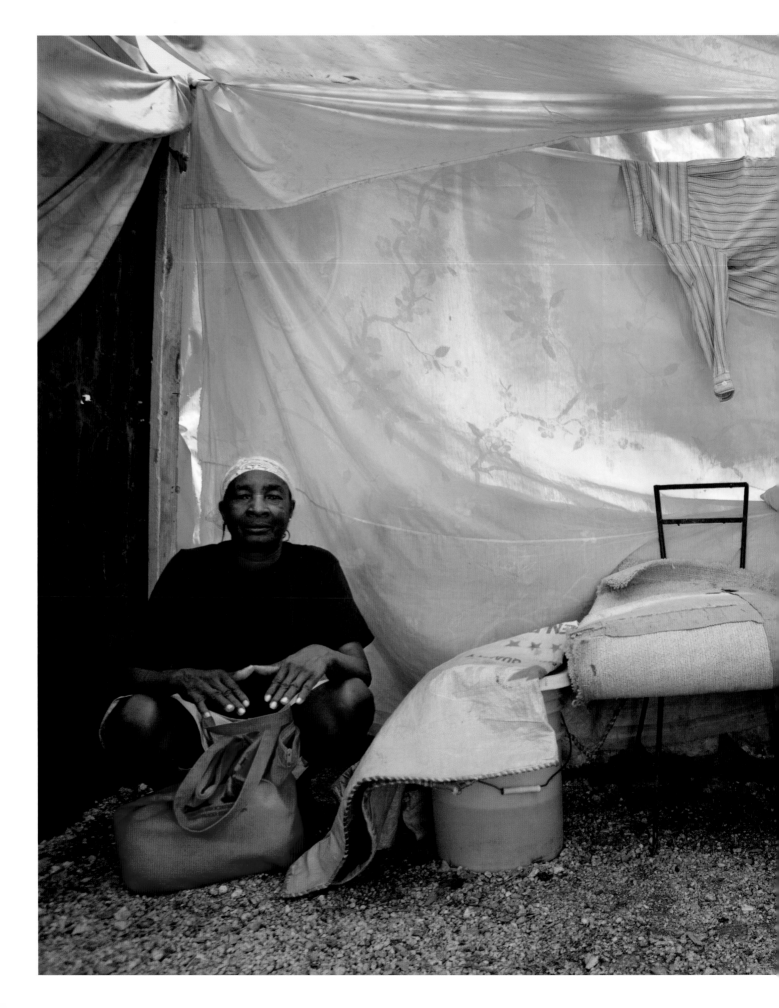

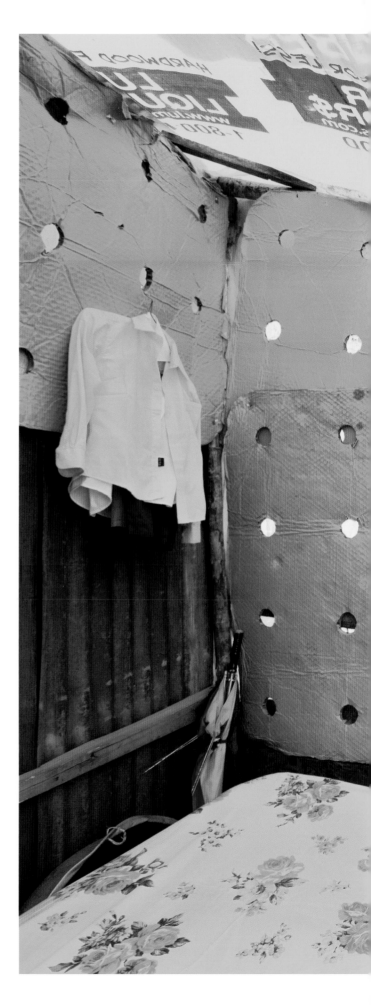

Handbag in Yellow Shack Interior, Delmas 32

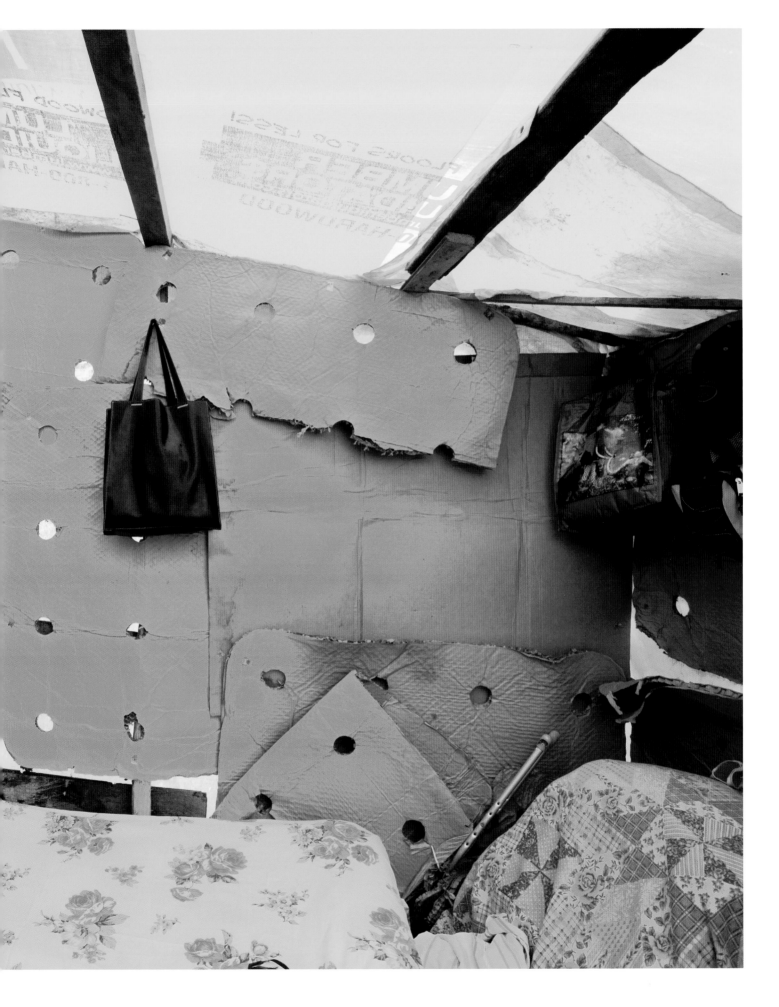

Immerone, Delmas 31

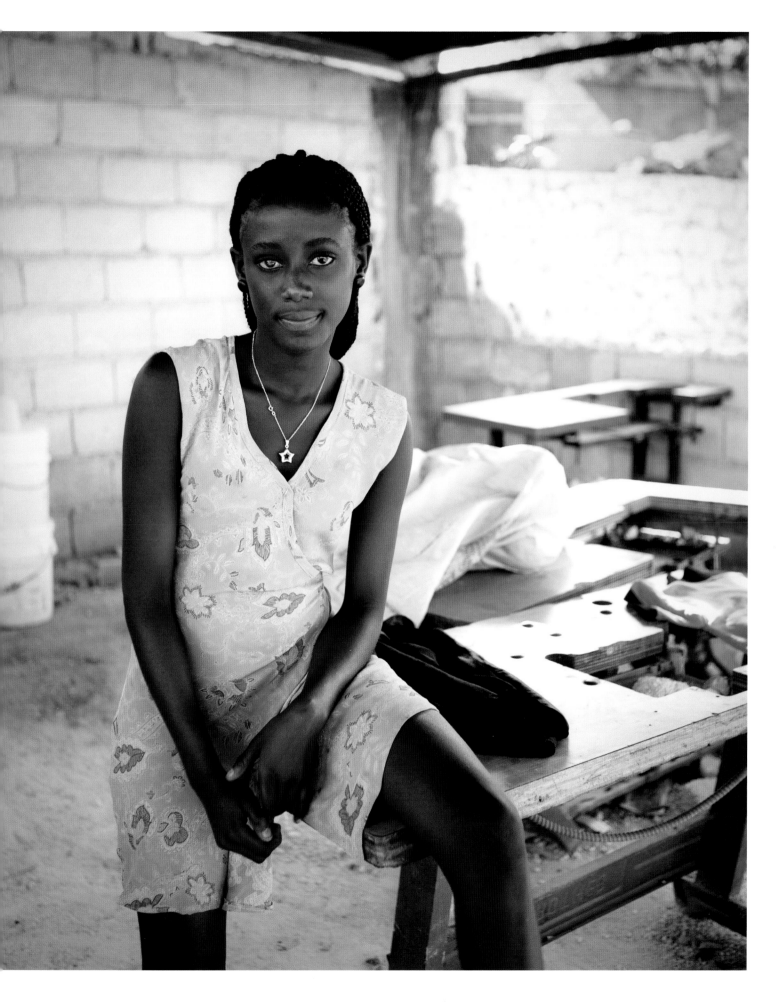

September 23, 2010

*I walked down the street to the tent community where I shot
during the last trip. I tried to find the same tents but everything
had changed. In fact there are no tents now. Instead there are
makeshift shack structures that are covered in USAID (United
States Agency for International Development) tarps. The tarps
are said to be more effective shelter than the tents and seem
to be covering almost 90 percent of all shacks in the camps of
Port-au-Prince. However, more and more the camps resemble
permanent shantytowns rather than temporary housing.*

**Man in USAID Tarp Shack, Delmas 31**

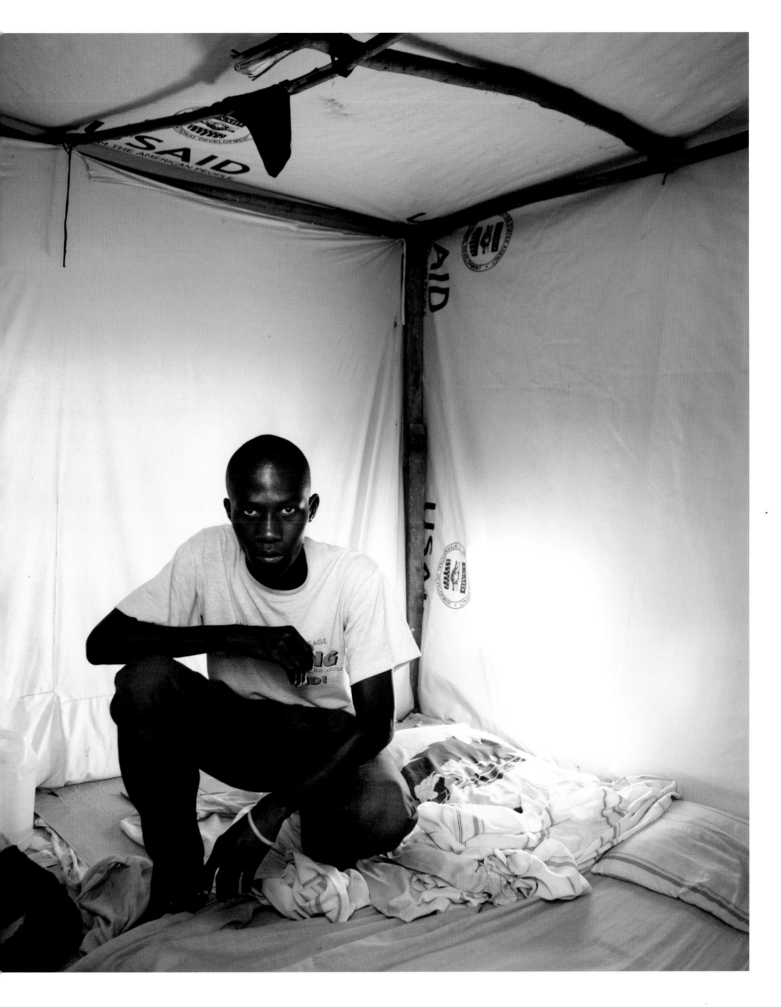

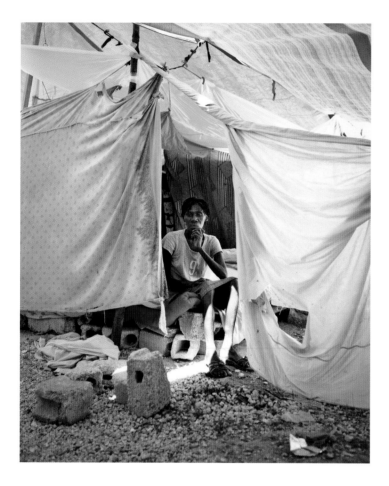
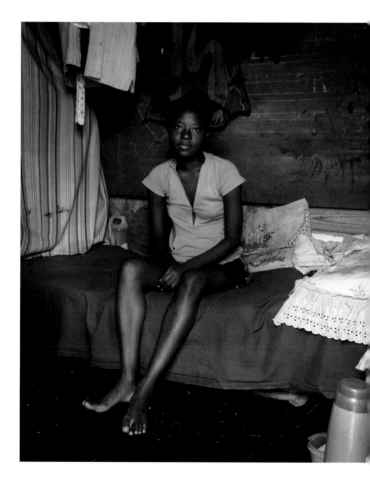

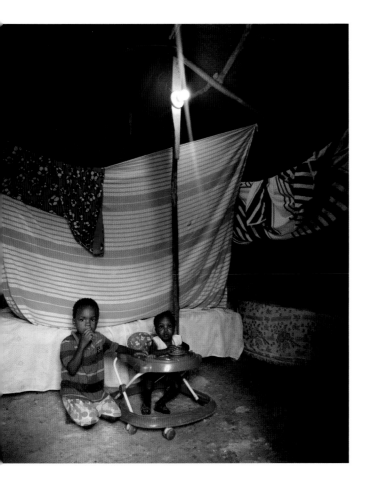 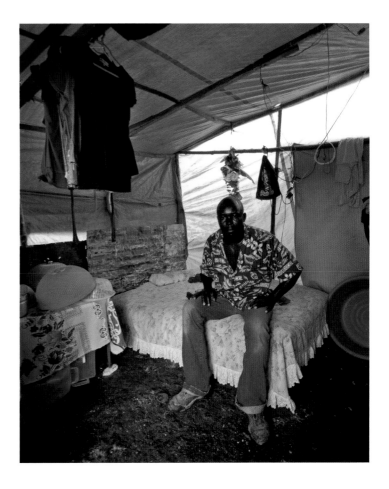

Portraits in Shack Interiors, Port-au-Prince

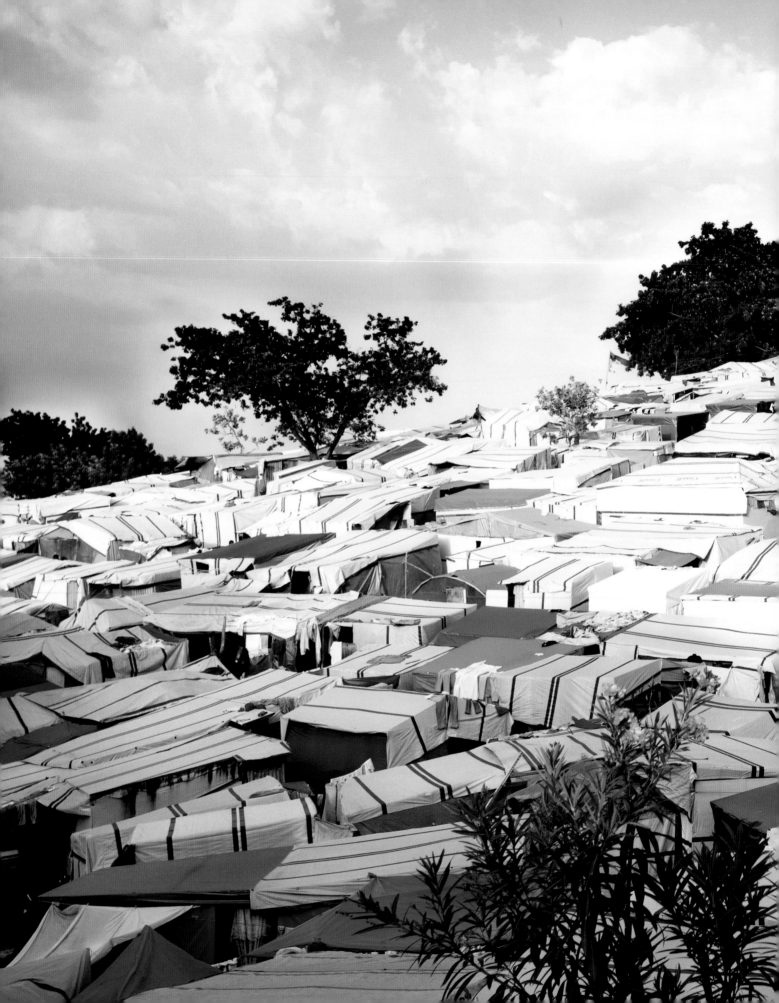

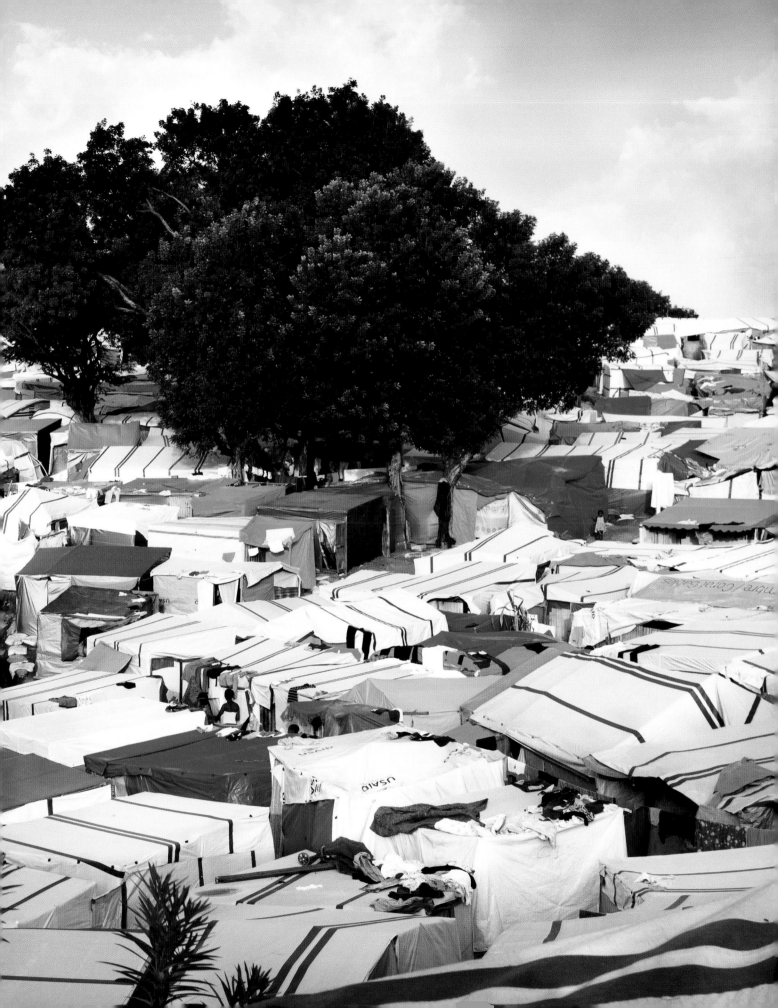

Tarp-covered Shacks, Pétionville Camp (previous page)

A Moment Alone, Delmas 31

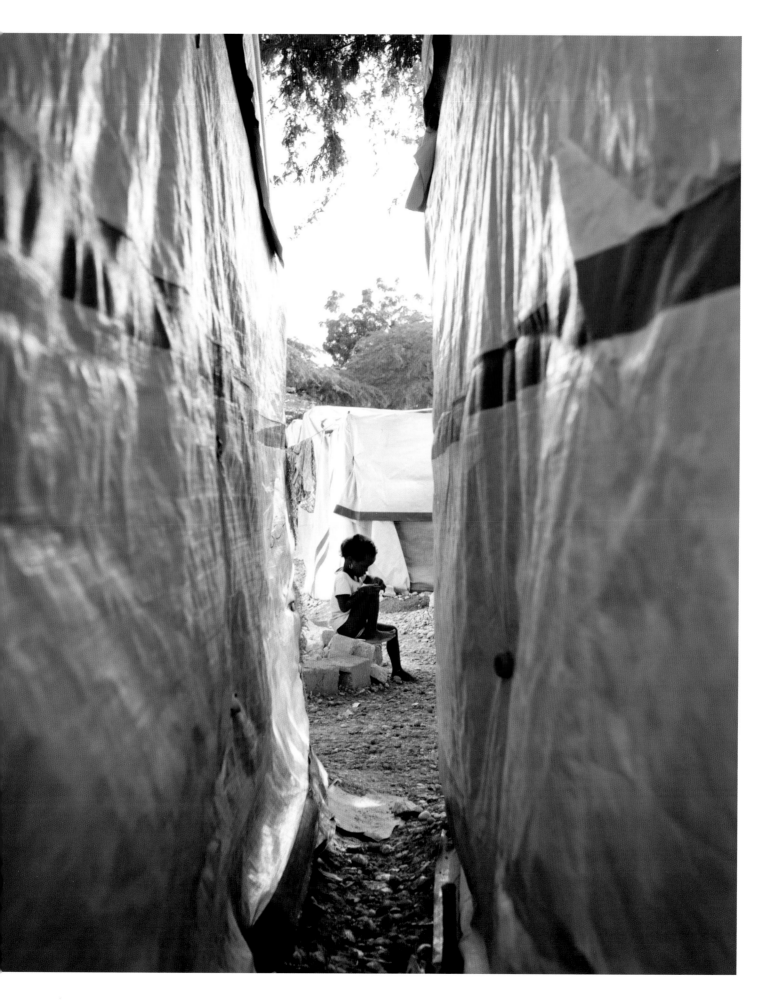

Woman in Orange Shack, Pétionville Camp

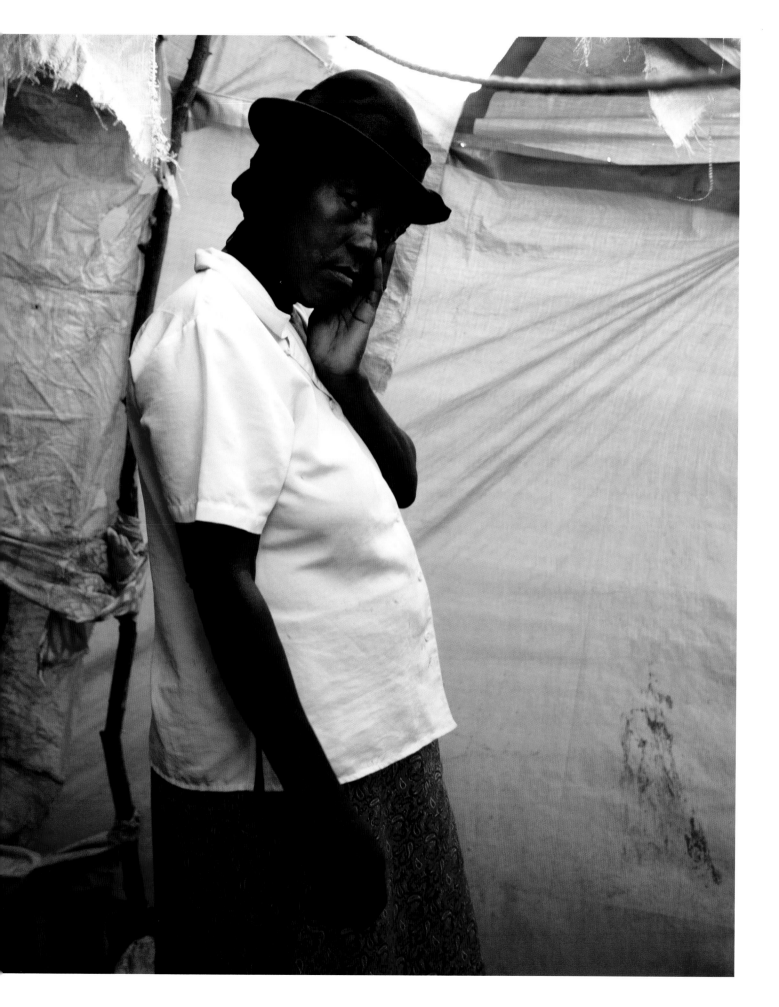

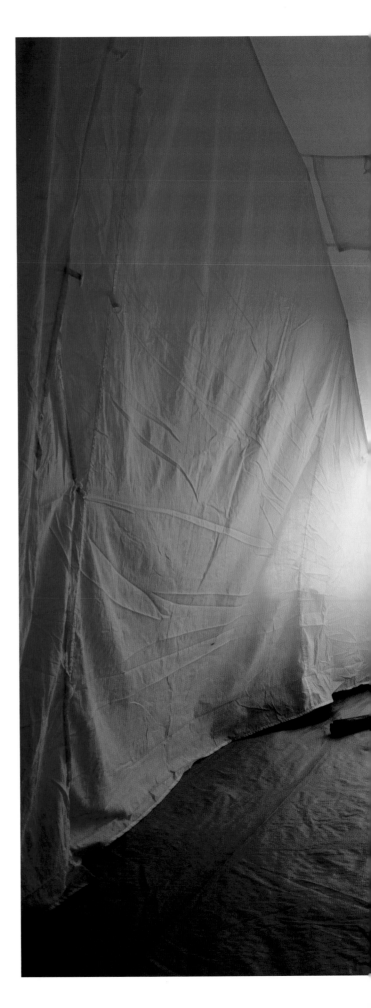

Blue Tent Interior, Airport Camp

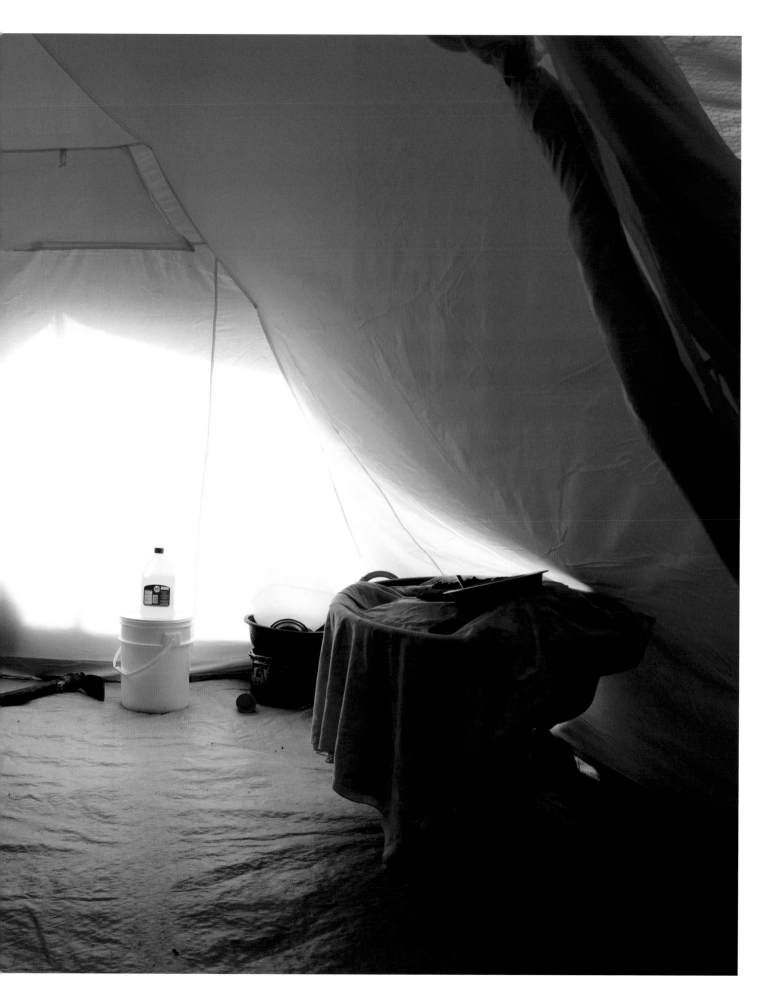

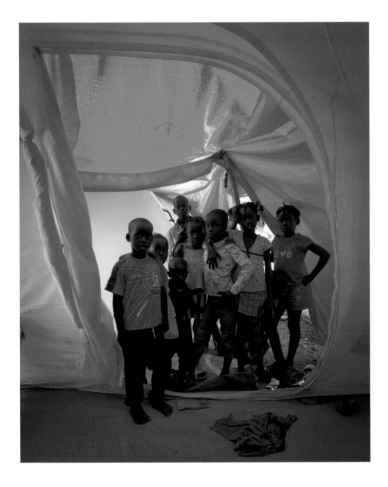
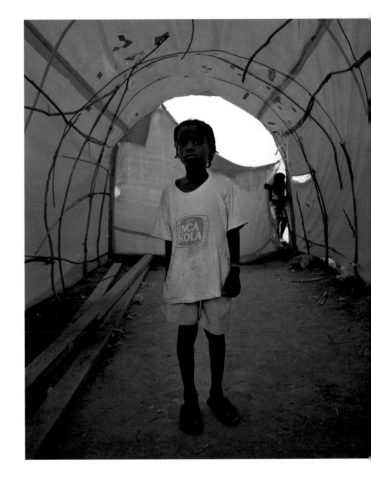

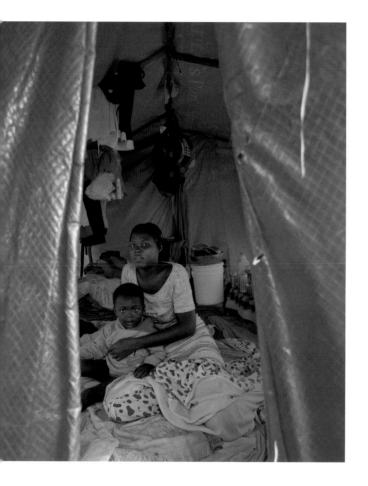

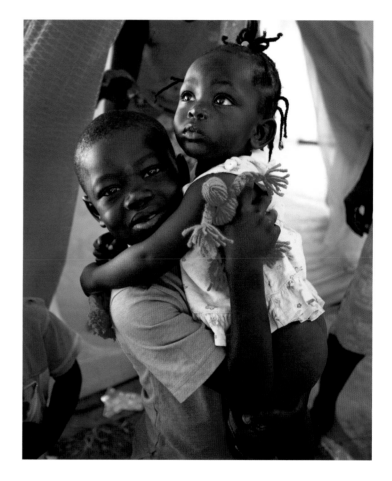

Portraits in Blue Tent Interiors, Port-au-Prince

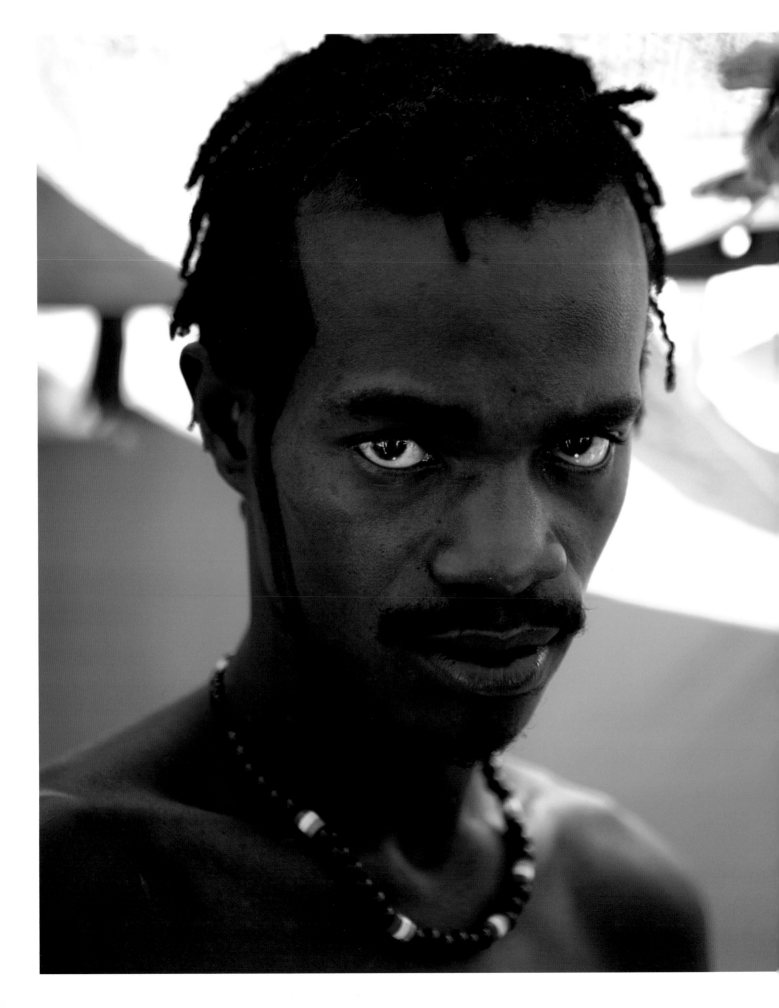

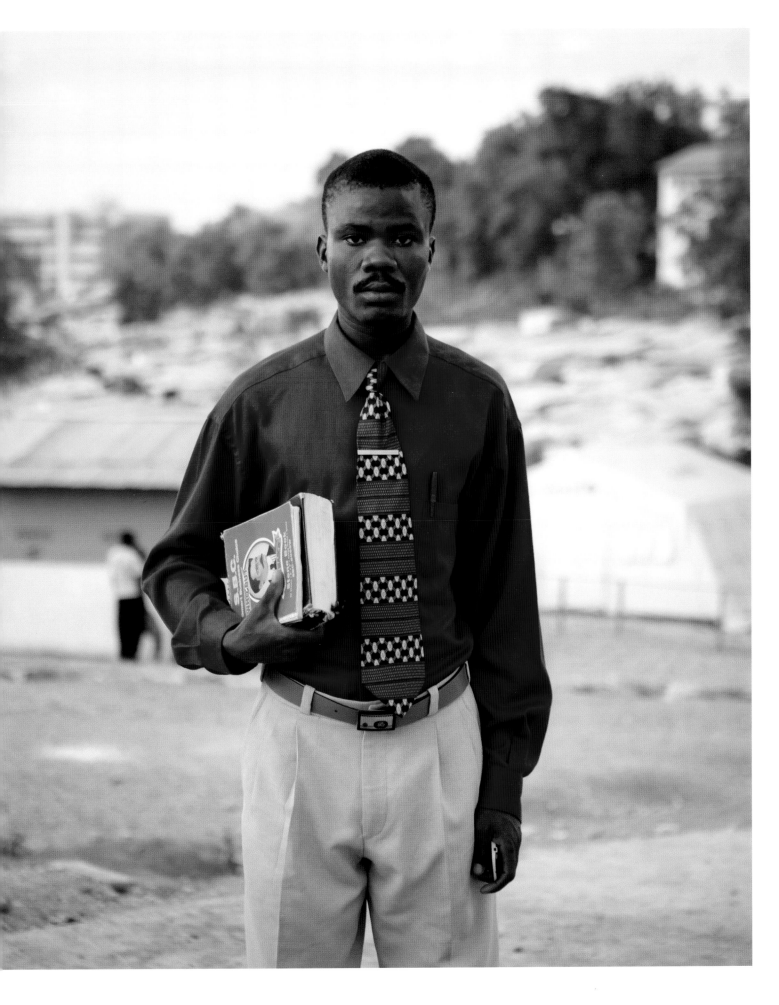

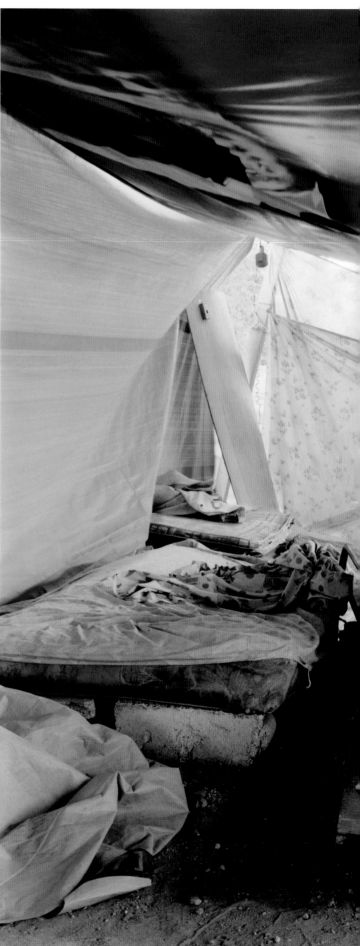

Man with Shoe Polish Sideburns, Delmas 31
Man Coming from Work, Delmas 32
(previous page)

Premium Heineken, Delmas 31

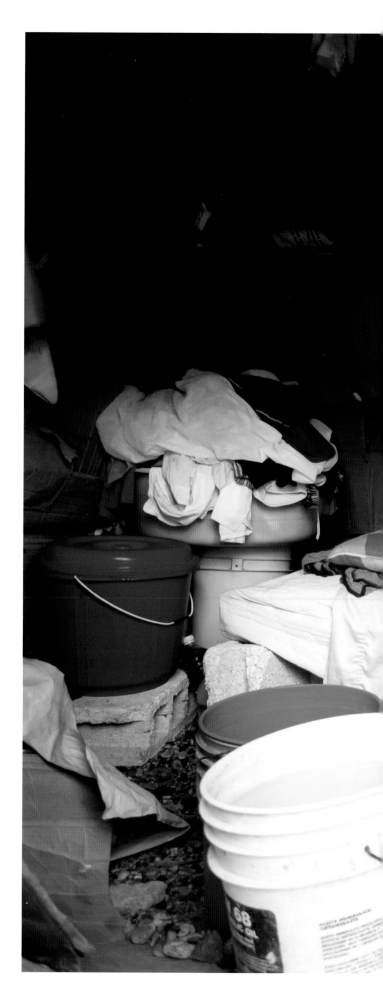

Woman Smoking, Delmas 31

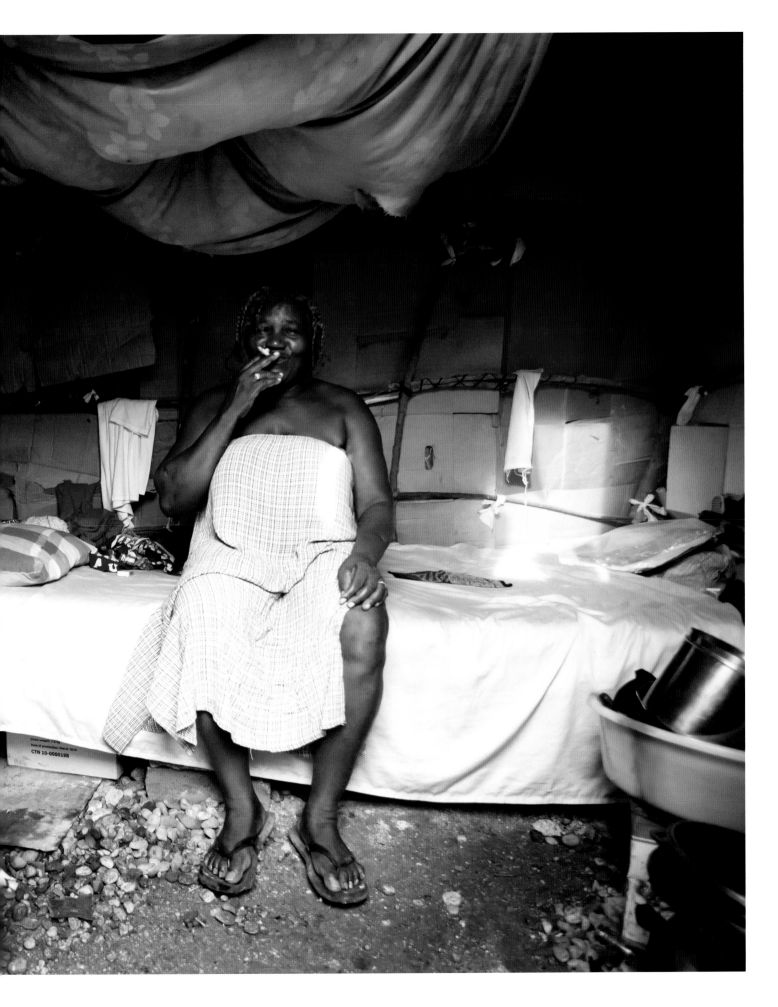

Charcoal Worker, Cité Soleil

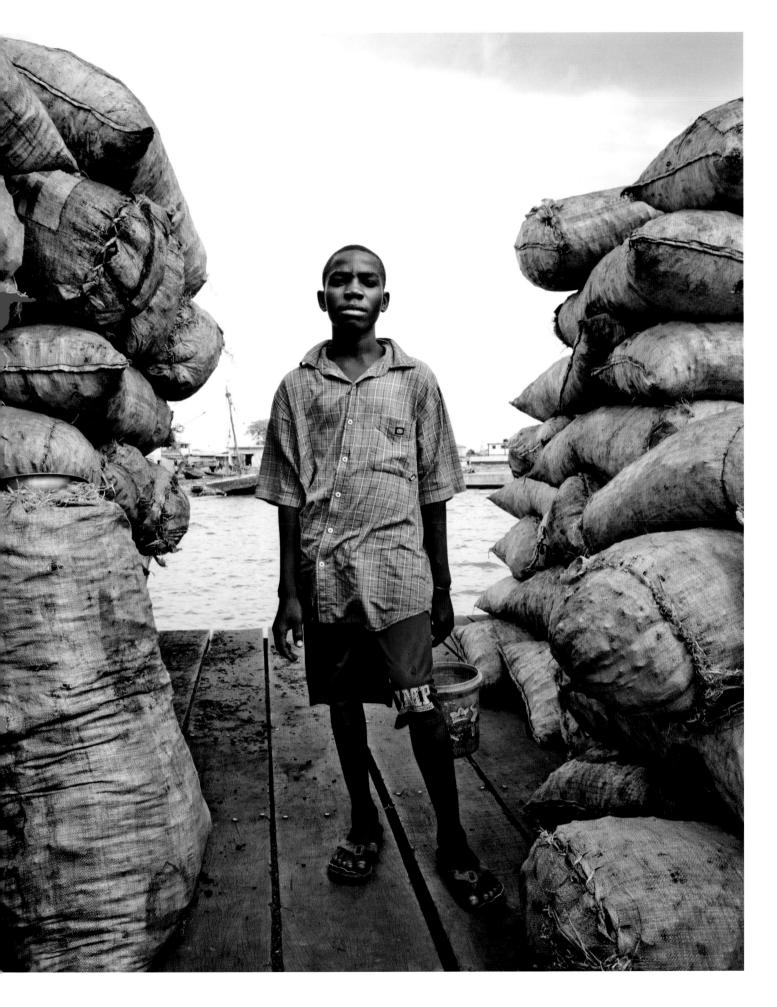

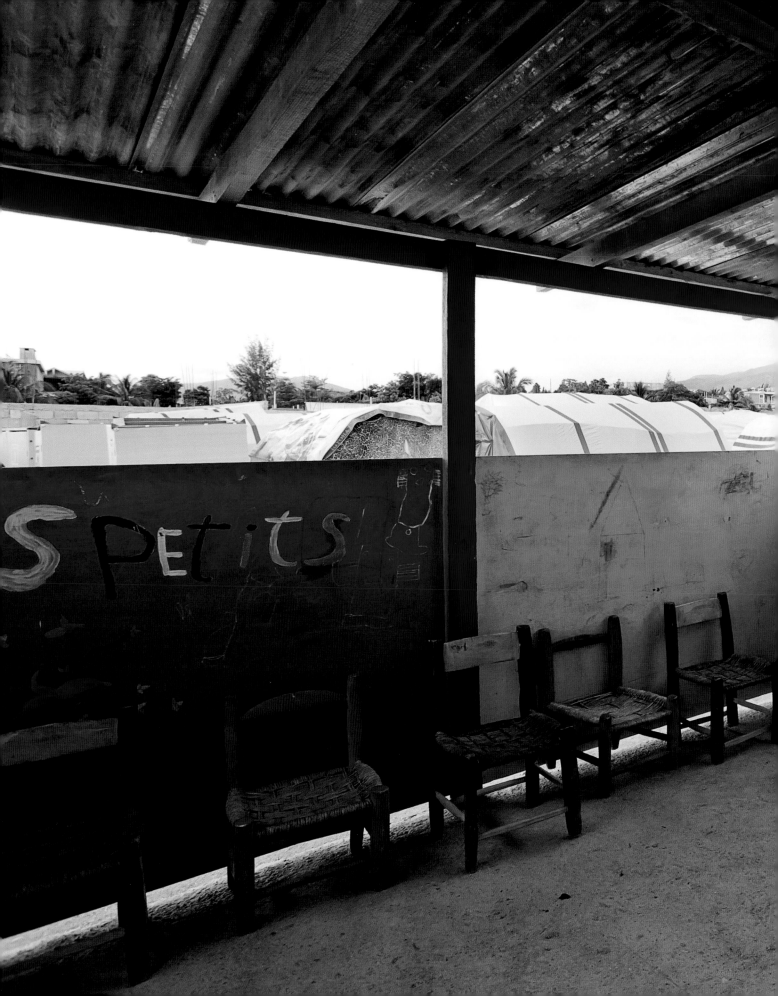

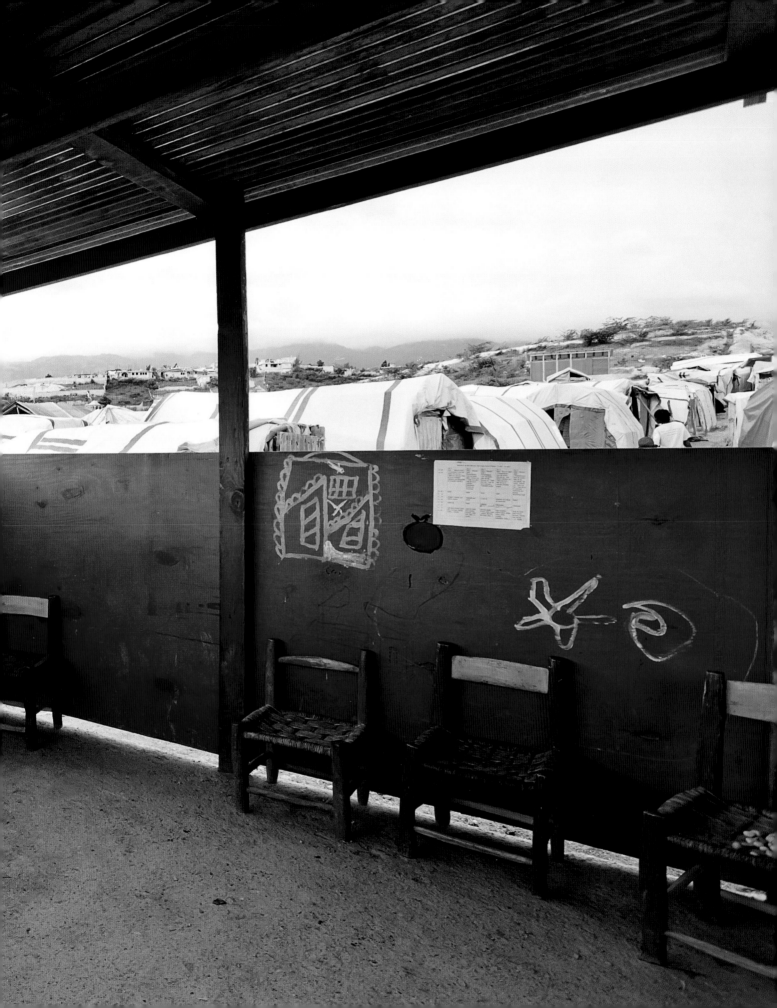

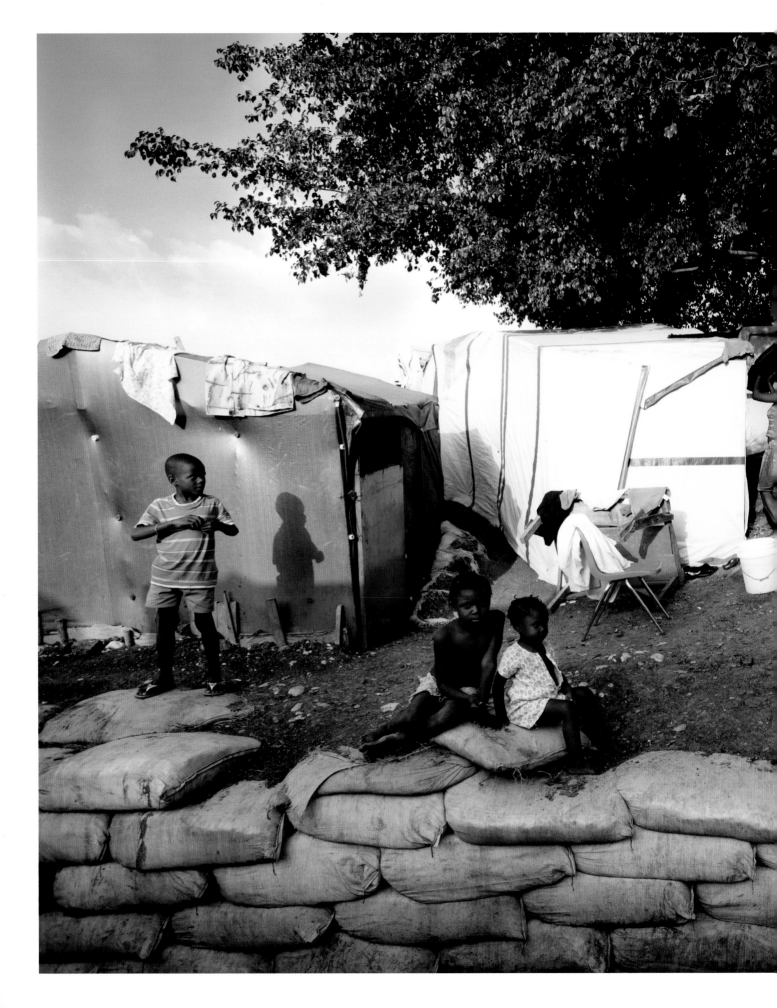

March 7, 2010

*Everyone wants to live in Pétionville Camp, which is run by J/P HRO. Housing over 50,000 residents, this camp is by far the most organized and developed of them all. It contains a hospital, a marketplace, a school, multiple churches, beauty salons, an art center, and an intricate system of gutters made from sandbags.*

IRC Pre-school, Refugee Camp (previous page)

Daily Life, Pétionville Camp

March 9, 2010

*The children and women work so hard to carry the heavy,*
*precious water. The children love to have their photo*
*taken, posing over and over. It seems to really bring smiles*
*to their faces. We are happy to take hundreds of photos of*
*them. But when they are not posing I can see the sorrow*
*and pain in their downward stares. It is easy to see how a*
*smile is a huge gift in this tragic environment.*

**Girl Smiling Carrying Water, Cité Soleil**

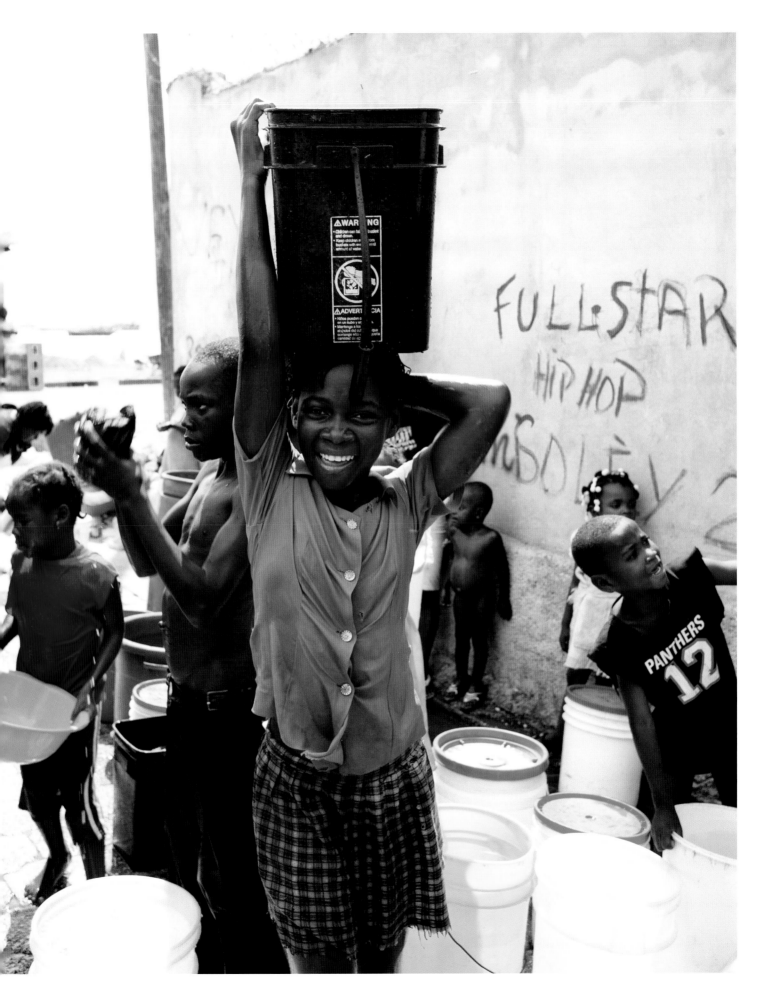

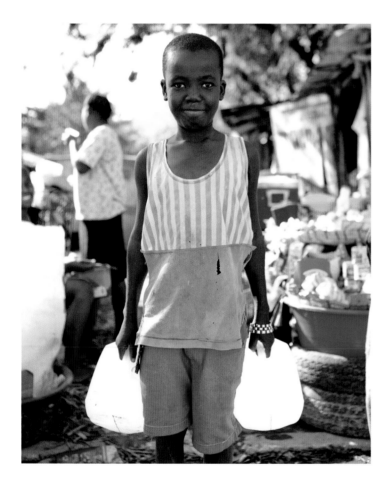
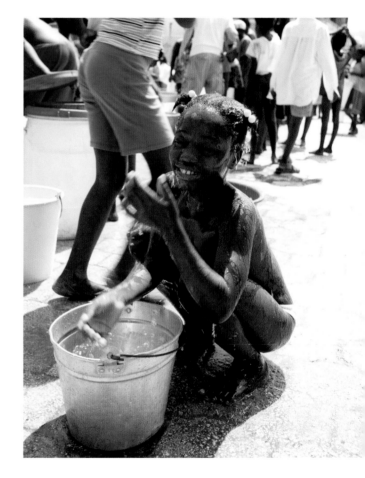

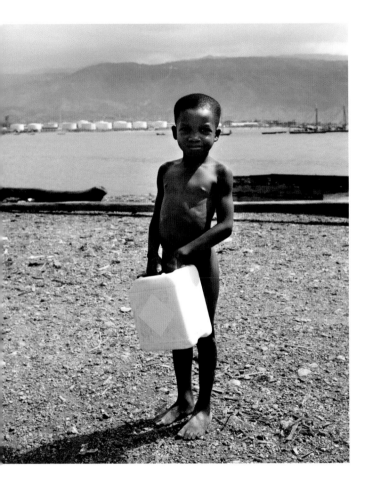

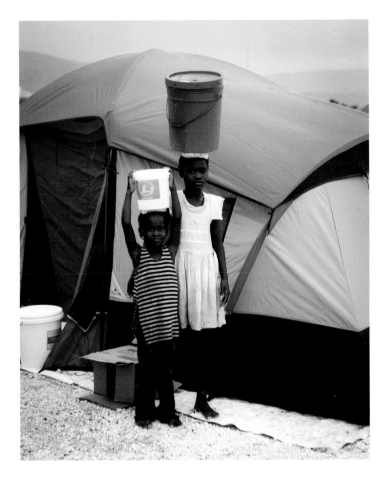

Children Carrying Water, Port-au-Prince

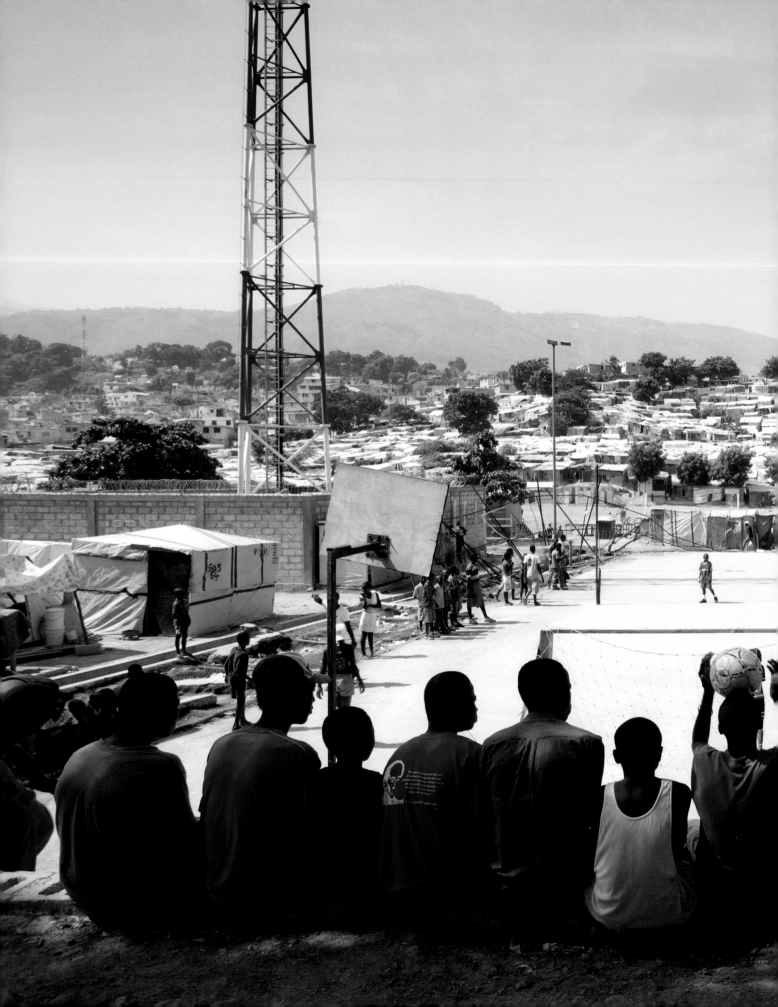

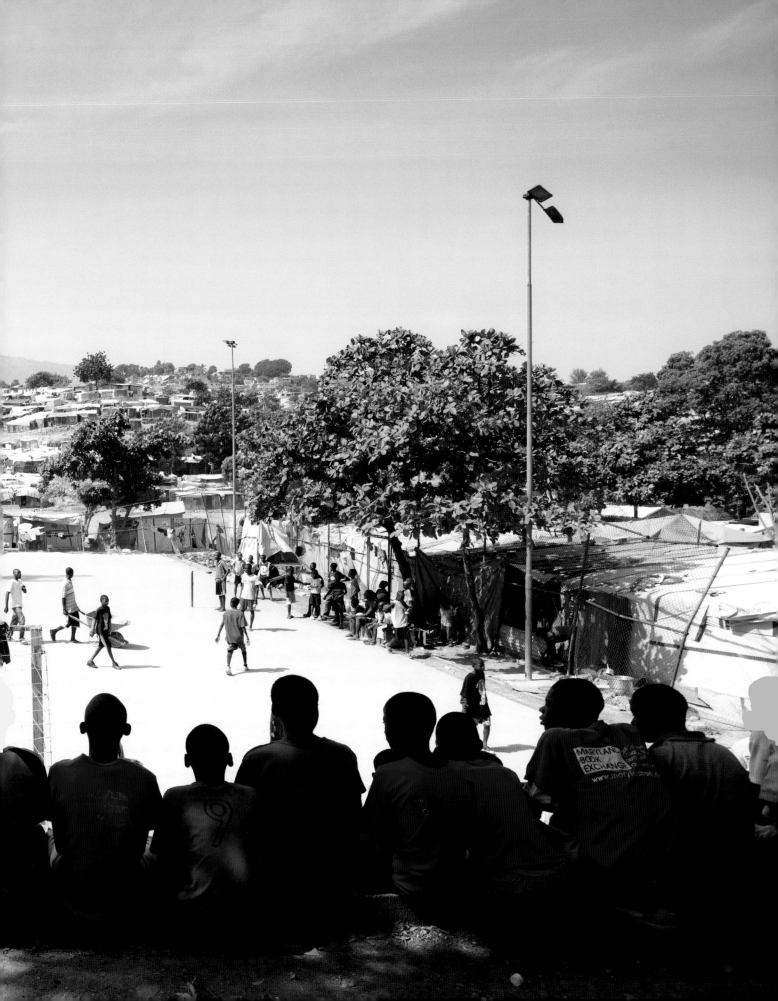

Watching Soccer, Delmas 32 (previous page)

Boy with Water, Pétionville Camp

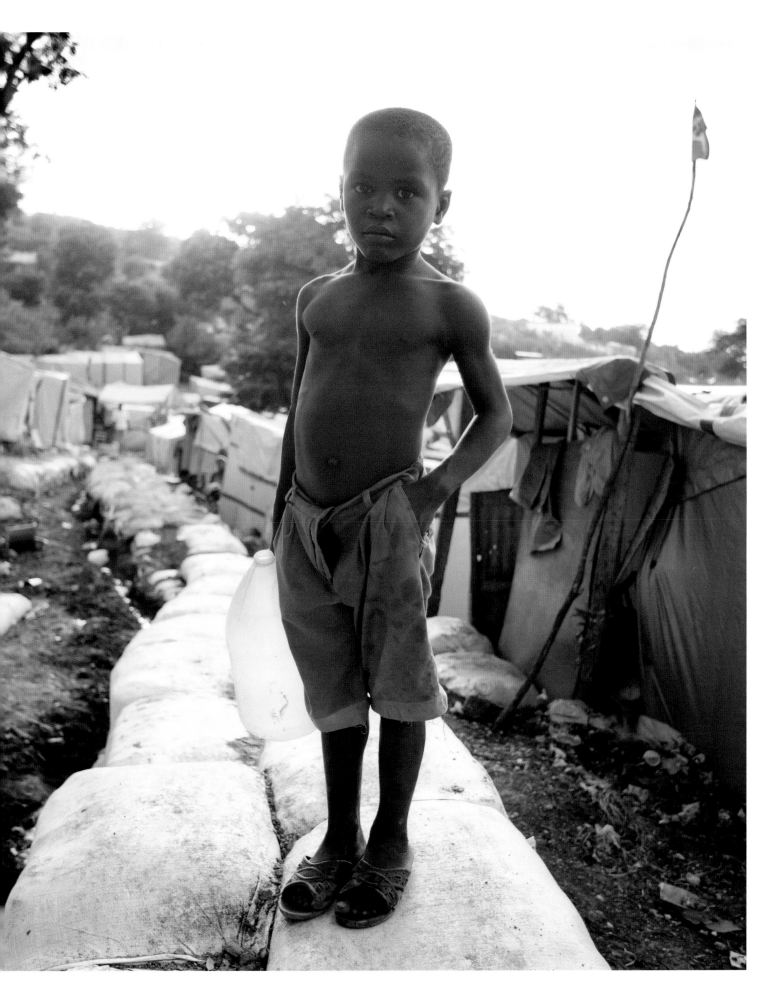

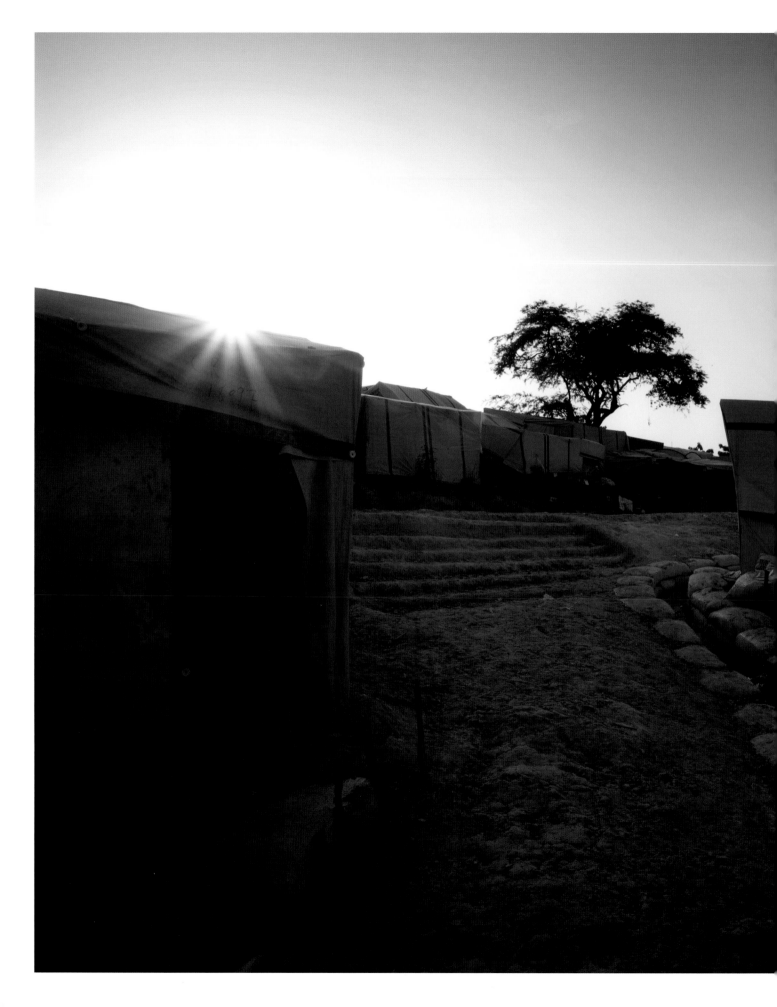

Gutter and Steps, Pétionville Camp

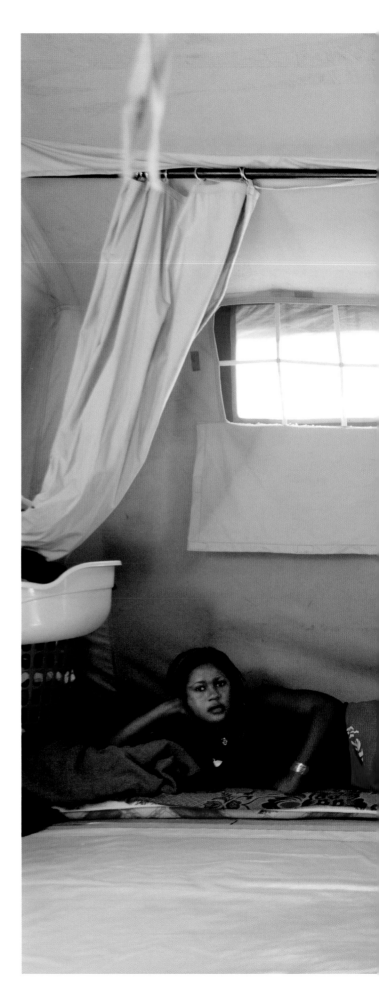

Girls Lying in Bed, Bobby Duval's Soccer Field

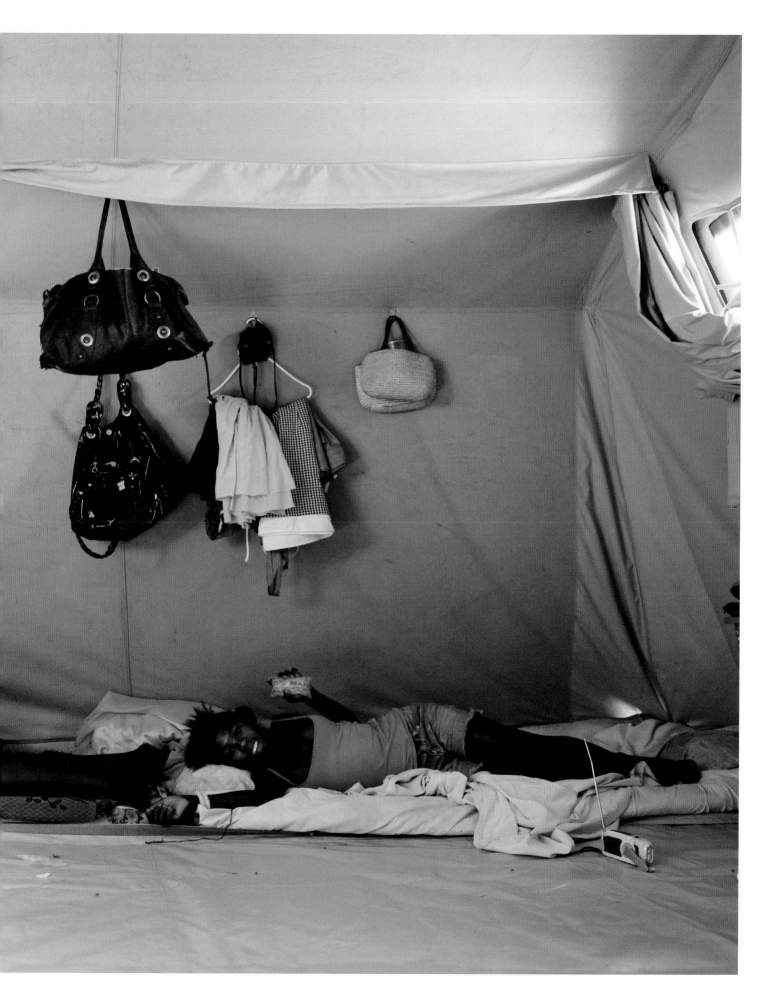

Julie Studio Beauté, Pétionville Camp

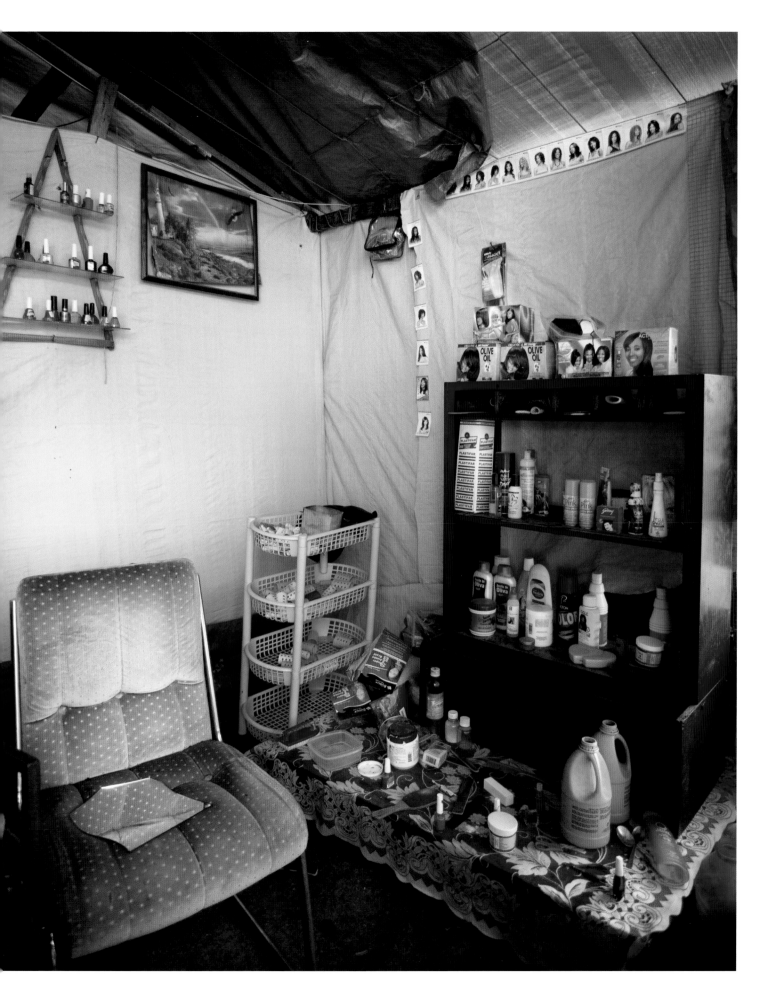

Elderly Woman and TV, Delmas 32

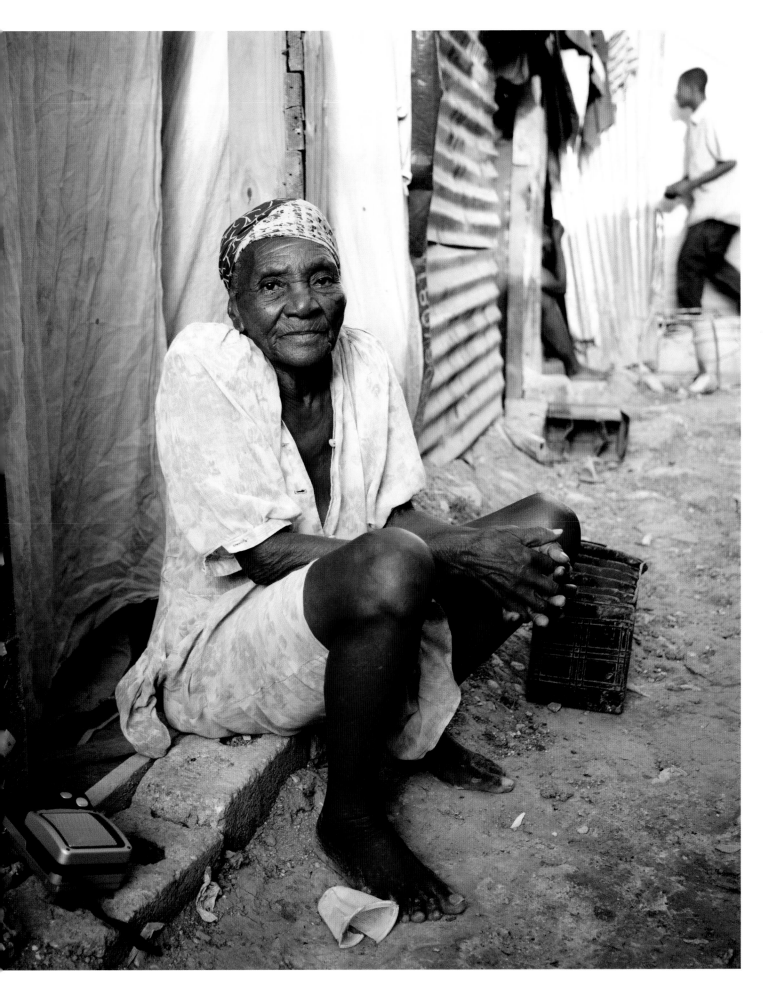

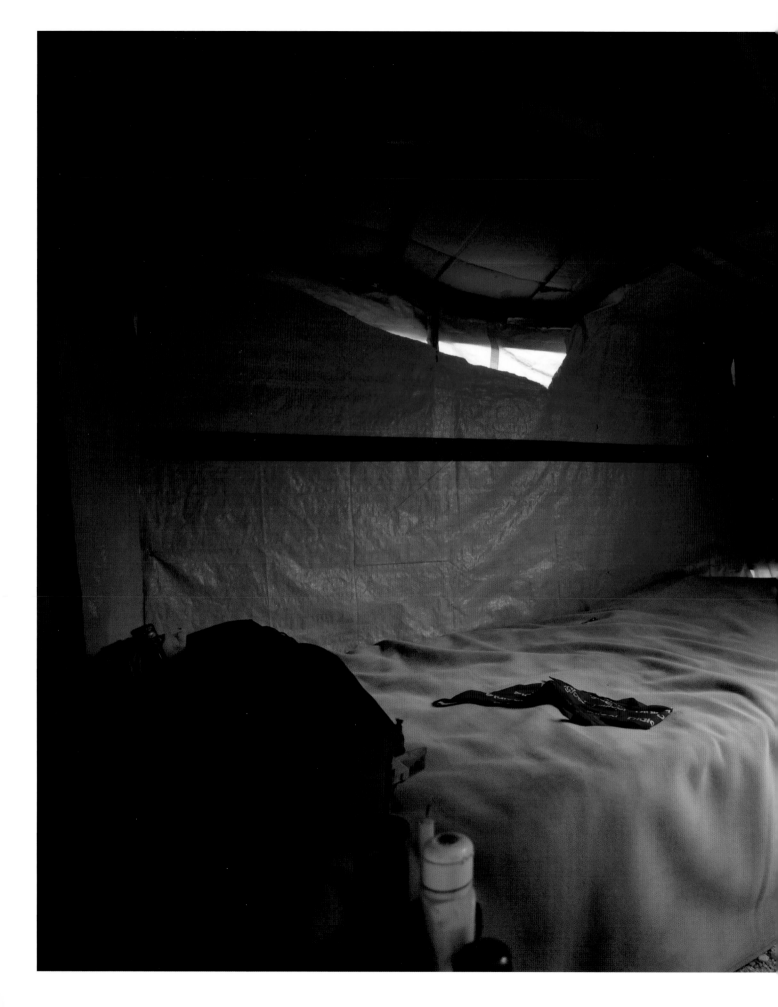

Shack Interior with Afternoon Light, Delmas 31

Girl in Doorway, Delmas 32

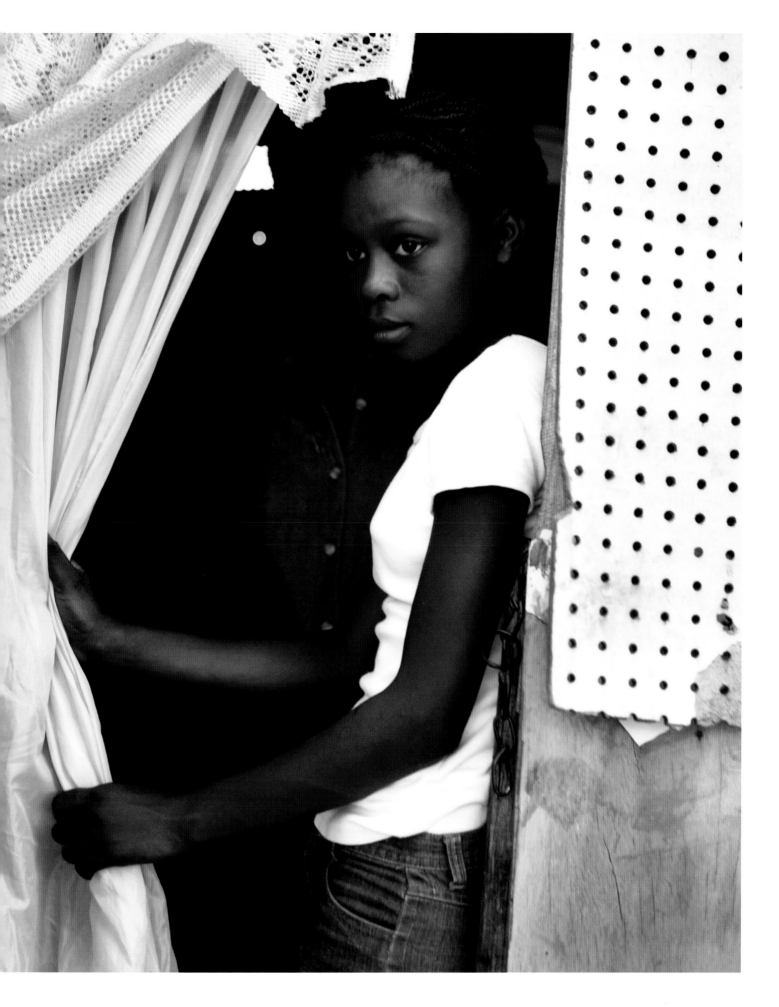

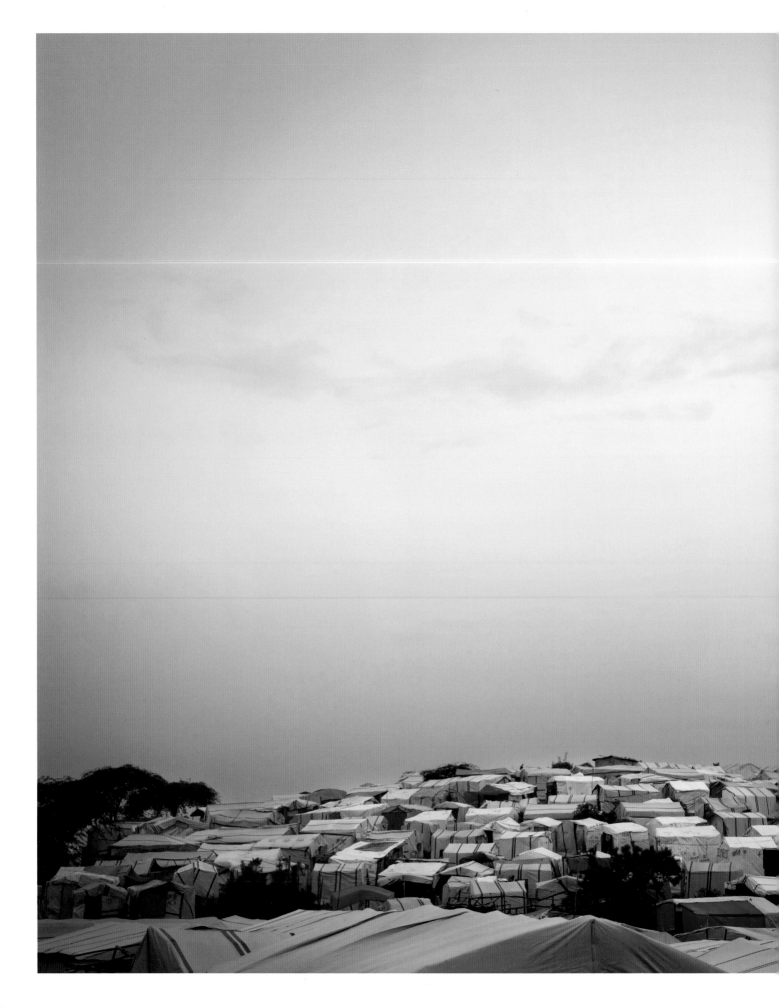

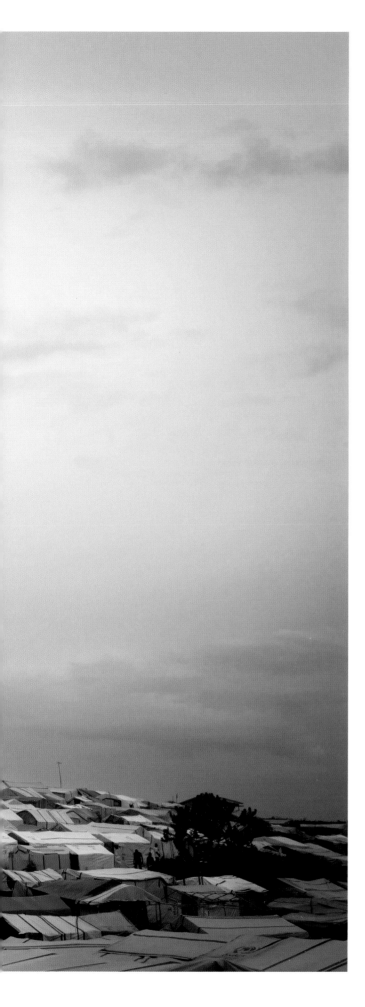

Tarp-Shack Hill, Tabarre 52

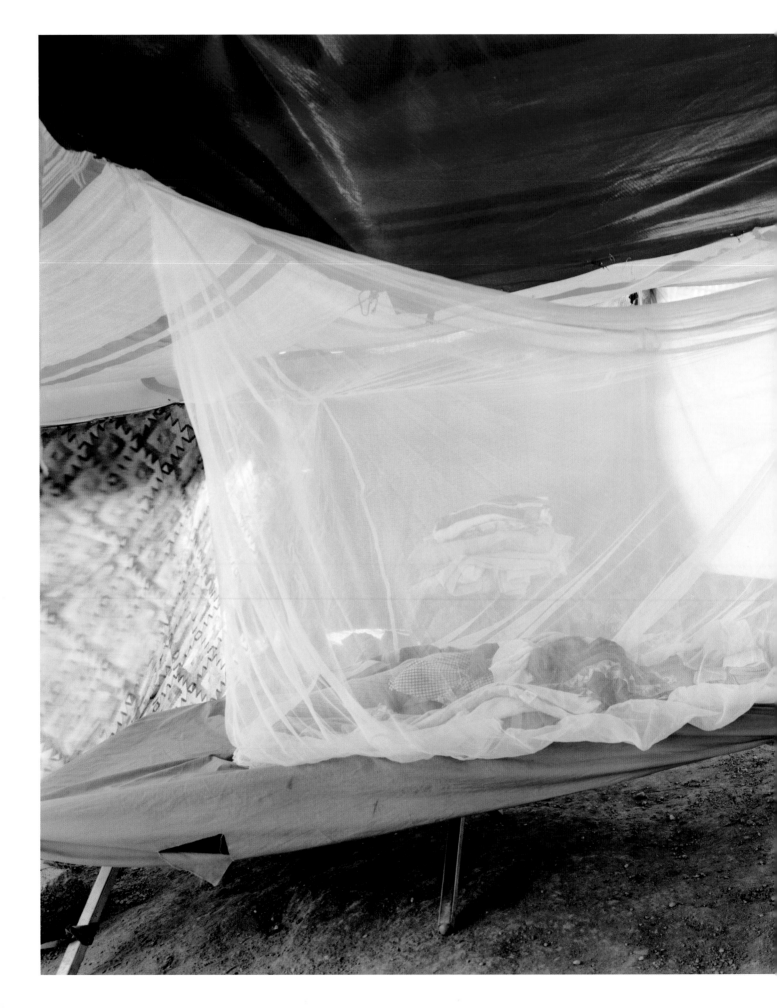

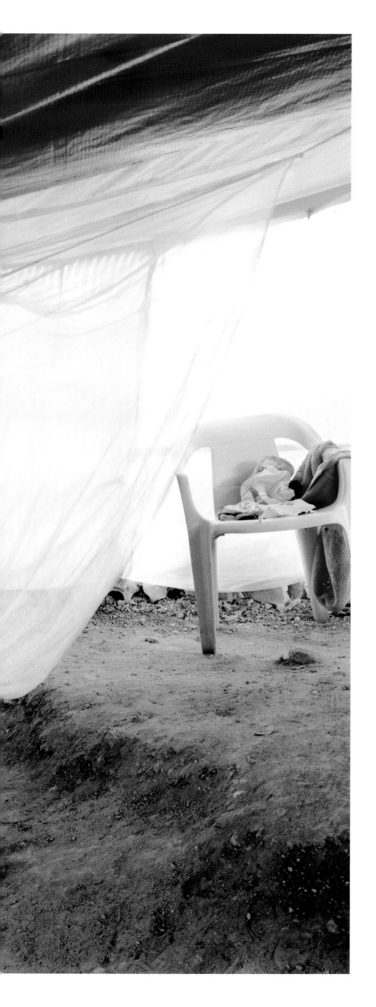

Baby Sleeping, Delmas 31

March 10, 2010

*Wilson, our translator, took me to his tent next to the airport. He has a white tent with good ventilation and lots of soft light. He lives there with his sister and her newborn daughter. His sister's husband died in the earthquake. Eight days later their baby was born. On the other hand, Frank, our other translator, only has a tarp and a piece of foam for his family of eight. Wilson's camp has clean water and latrines provided by the Red Cross, but Frank's does not. Frank says his daily pay of forty U.S. dollars for being our translator will feed his whole family for a month.*

Wilson's Tent, Airport Camp

September 24, 2010

*I'm on the plane returning from my second trip to Haiti. This has been an indescribable experience. I wish I were living there right now, volunteering in the camps and photographing daily life. I really hope my photos can do something to help the Haitian people struggling to survive in these camps. My biggest fear is that these compelling photographs are never seen and thus do nothing for the people of Haiti. I feel that document- ing these tragic living conditions is my calling and that living in the Caribbean for so many years, and shooting the 2004 tsunami and Hurricane Katrina, has prepared me for this experience. In my heart, these are my people and the Caribbean is my home.*

Woman and Her Belongings, Delmas 31

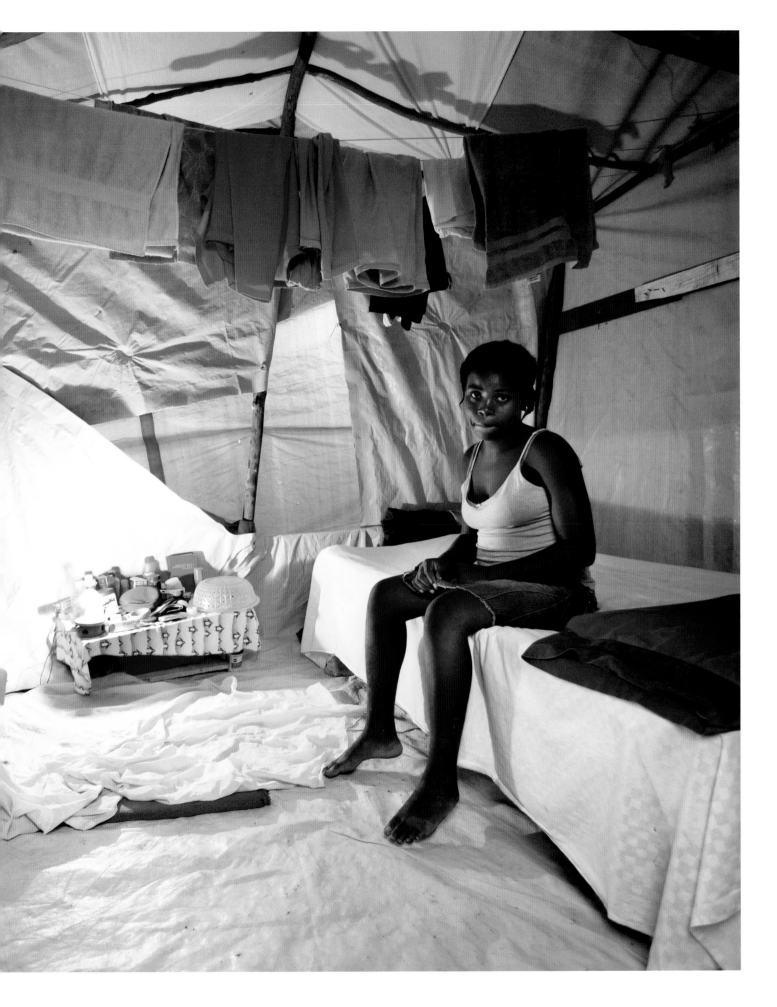

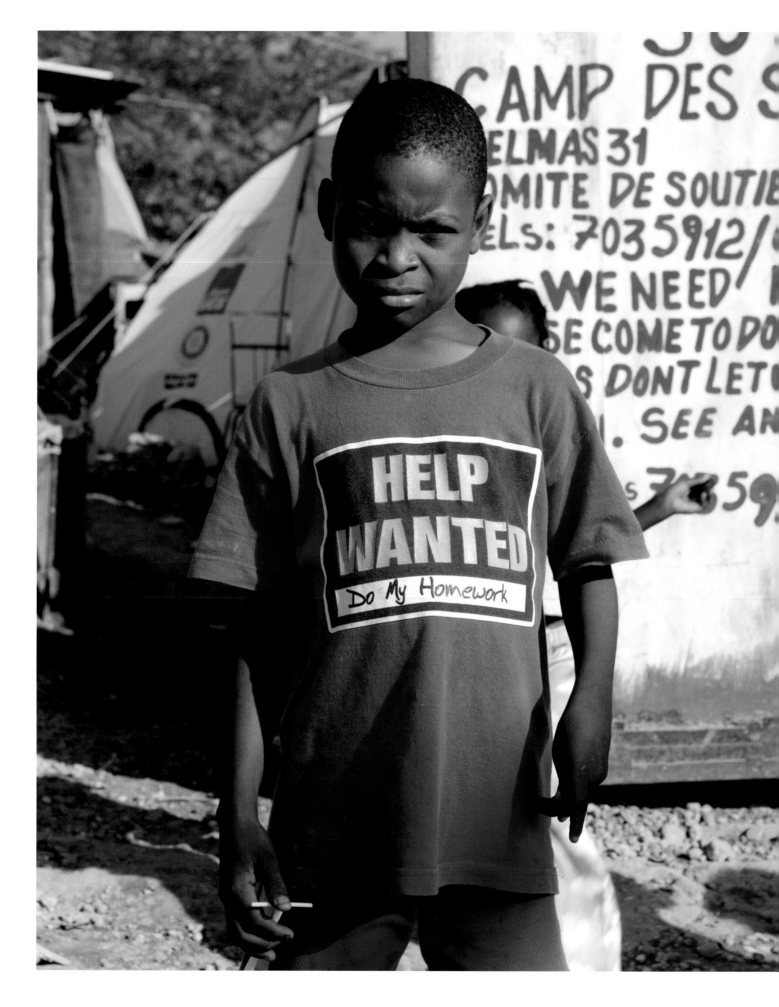

## J/P HAITIAN RELIEF ORGANIZATION

Our mission at J/P HRO is simple: to save lives and bring sustainable programs to the Haitian people quickly and effectively. Since the devastating earthquake struck Haiti on January 12, 2010, J/P HRO has been on the ground, working every day to help Haitians not only recover from the earthquake, but to build a better future. Founded by actor and humanitarian Sean Penn, J/P HRO has strived to keep the plight of the Haitian people in the public eye in America and throughout the world.

J/P HRO works with both government and non-government agencies to deliver immediate results where the need is greatest. Efforts include, but are not limited to, managing a camp of 55,000 displaced people, providing emergency medical and primary care services, delivering badly needed medical equipment and medicine, distributing food and water purification systems, and removing rubble from streets and neighborhoods.

J/P HRO has quickly become a leader among Haitian relief organizations. We have been recognized by major international organizations for our camp management, camp resident relocations, and rubble removal processes. As the next phase of work in Haiti unfolds, we strive to continue to be leaders—finding new and more efficient ways of bringing relief and empowerment to the people of Haiti.

J/P HRO's goal is to help lift the nation of Haiti out of the rubble and give the Haitian people a better life. Our organization is dedicated to empowering Haitians to return to their previous lives without dependence on outside organizations. We foresee a time when Haiti and the Haitian people stand on their own.
**www.jphro.org**

## HEALING HAITI

Healing Haiti is a faith-based organization working to bring clean water, food, housing, and education to the marginalized communities of Haiti. On their first mission trip in 2006, founders Jeff Gacek and Alyn Shannon travelled to Haiti to find extreme poverty, sanitation emergencies, and limited means toward accessing basic nutrition. In the spring of 2006, Healing Haiti gathered resources and invested in helping the poorest communities, renovating a school in the mountains of a rural town, a project that led the way to supplying additional humanitarian aid.

From 2007 to the present, Healing Haiti has improved the livelihoods and futures of Haitians through several initiatives. These include providing free monthly water to the slums of Cité Soleil, supporting an orphanage in Titanyen, and purchasing sixteen acres of land in this rural town where community residents can work toward sustainability. The strong partnerships Healing Haiti has established, and their collaborative work with Buya.org, allow these achievements to grow and expand.
**www.healinghaiti.org**

## THE GLOBAL SYNDICATE

The Global Syndicate is a wide and growing network of friends and business associates located across the world, with a shared vision and concerted passion to impact issues that plague humanity. We assess where fundraising is urgently needed, with an affinity for addressing gaps in education, health care, and economic prosperity. We harness massive resources to affect singular concerns of importance, and we generate informative, exciting, and star-studded campaigns to raise both immediate dollars and long-lasting awareness. We deliver fundraising proceeds via grants to nonprofit organizations, both large and small, with proven capabilities to execute innovative and sustainable initiatives that positively impact communities in need. Each campaign produced by The Global Syndicate attacks concerns of the moment, and is therefore crafted to be unique in its approach and impact.

We are thrilled to partner with Wyatt Gallery and Umbrage on the production of *Tent Life: Haiti* as part of our current campaign, The Haiti Project! We believe it will serve the Haitian community as well as the broader universe through its depiction of the people we seek to uplift in such a beautiful light. The Global Syndicate will use all proceeds that are generated from the sale of this book to benefit The Ciné Institute. The Ciné Institute seeks to stimulate economic activity in Haiti through the creation of a vibrant film industry. Significant strides have already been made and one can't help but draw the parallels between the symbolism of Gallery's work and the mission of Cine. We humbly thank you for your support.
**www.theglobalsyndicate.org**

## THE AGRONOMIST
*A film by Jonathan Demme*
Profiling Jean Dominique, a Haitian radio journalist and human rights activist assassinated in 2000, including historical footage of Haiti's tumultuous past and interviews with Michèle Montas, Dominique's heroic wife.

## ALL SOULS' RISING
*by Madison Smartt Bell*
This first book in a trilogy of novels about the Haitian Revolution tells the story of the slave revolt that ended colonial rule in Haiti in the eighteenth century. The novel won the Anisfield-Wolf Award in 1996, and was a National Book Award finalist. Bell has also penned *Toussaint Louverture: A Biography*, about the leader of Haitian Revolution.

## ARISTIDE AND THE ENDLESS REVOLUTION
*a film by Nicolas Rossier*
The untold story of the 2004 coup in Haiti, with its systemic violence and human rights violations. Interviews with Jean-Bertrand Aristide, Paul Farmer, U.S. Assistant Secretary of State Roger Noriega, Haitian leader Gérard Latortue, Maxine Waters, Jeffrey Sachs, Noam Chomsky, Danny Glover, and many Haitian voices detail how international interests have contributed to the historical poverty of Haiti.

## THE BLACK JACOBINS:
## TOUSSAINT L'OUVERTURE AND THE SAN DOMINGO REVOLUTION
*by C.L.R. James*
Classic and impassioned account of the first revolution in the Third World (1794–1803), that became the model for liberation movements from Africa to Cuba.

## BREATH, EYES, MEMORY
*by Edwidge Danticat*
The award-winning Haitian-American writer evokes wonder, terror, and heartache with vibrant imagery and narrative grace that bear witness to her people's suffering and courage. *Breath, Eyes, Memory* was chosen as an Oprah's Book Club book, while her non-

fiction account of immigration, *Brother, I'm Dying*, won the Dayton Literary Peace Prize. Other outstanding books by Danticat include *Krik? Krak!* and *The Dew Breaker*. She won the prestigious McArthur Award in 2009.

## CARIBBEAN TRANSFORMATIONS
*by Sidney Mintz*
A fascinating exploration of sugar over the past 1,000 years that analyzes how the highly labor-intensive nature of the industry caused the British to look to Haiti to find cheap or free labor. With sugar came slavery, and slaves who did the plantation work generally worked in the Caribbean while the product they created was delivered to British aristocracy. Mintz also (with Sally Price) edited *Caribbean Contours*, an authoritative introduction to Caribbean history, politics economics, demographics, and culture.

## DAMMING THE FLOOD:
## HAITI, ARISTIDE, AND THE POLITICS OF CONTAINMENT
*by Peter Hallward*
Contemporary Haitian politics and U.S. policy, praised by Paul Farmer as, "Excellent, the best study of its kind, and by Noam Chomsky as "riveting, deeply informed.

## FROM COLUMBUS TO CASTRO:
## THE HISTORY OF THE CARIBBEAN 1492–1969
*by Eric Williams*
Separated by the languages and cultures of their colonizers, this arc of islands shares a common heritage and history: the story of sugar, inseparable from the history of slavery. A definitive work about a profoundly important but neglected and misrepresented area of the world.

## THE IMMACULATE INVASION
*by Bob Shacochis*
The story of Operation Uphold Democracy, the United States government's 1994 occupation of Haiti. Focusing on the Clinton administration's policymakers and the soldiers who implemented their plans, Shacochis explores the capacity for altruistic action amid human rights outrages.

**N THE PARISH OF THE POOR: WRITINGS FROM HAITI**
*y Jean-Bertrand Aristide, Amy Wilentz (transl.)*
ssays, sermons, and speeches from the heart.
.my Wilentz also wrote the wonderful first-person
arrative, *The Rainy Season: Haiti Since Duvalier,*
escribing life in Haiti in the late 1980s and giving an
nsightful picture of a country in turmoil.

**IFE IN A HAITIAN VALLEY**
*y Melville Jean Herskovits*
;roundbreaking anthropological account of Haiti as a
agic and revolutionary nation, experienced through
ne microcosm of one village, Mireabalais.

**OVE, ANGER, MADNESS: A HAITIAN TRILOGY**
*y Marie Vieux-Chauvet*
riptych of novellas, portraying people struggling to
urvive dictatorship and oppression, recently published
n English (with an introduction by Edwidge Danticat).
nitially suppressed when it was first released in French
n 1968 during François "Papa Doc" Duvalier's Haitian
eign of terror.

**MOUNTAINS BEYOND MOUNTAINS:**
**HE QUEST OF DR. PAUL FARMER, A MAN WHO**
**VOULD CURE THE WORLD**
*y Tracy Kidder*
he astounding backstory of Farmer and Partners In
lealth.

**ELL MY HORSE:**
**OODOO AND LIFE IN HAITI AND JAMAICA**
*y Zora Neale Hurston*
he amazing novelist and anthropologist Zora Neale
lurston visited Haiti in the 1930s, and wrote this
ascinating study.

**HE SERPENT AND THE RAINBOW:**
**HARVARD SCIENTIST'S ASTONISHING JOURNEY**
**NTO THE SECRET SOCIETIES OF HAITIAN VOODOO,**
**OMBIS AND MAGIC**
*y Wade Davis*
tour into Haitian "secret societies," including Zombi
nyths, and the use of a pharmocopoeia of toxins and

anesthetic drugs that, in Haiti, prove to be a mechanism
of social justice.

**THE USES OF HAITI**
*by Paul Farmer; Introduction by Noam Chomsky;*
*Foreword by Jonathan Kozol*
Harvard-based Farmer, who alternates research with
medical practice in rural Haiti, offers an indictment of
American foreign policy. Traces Haiti's long-standing
injustice from the sufferings of the eighteenth century
slave economy and the post-revolution establishment
of a still-persistent feudal economy, to the U.S. Marine
invasion in 1915 and subsequent support for tyrants
like "Papa Doc" Duvalier.

**WALKING ON FIRE:**
**HAITIAN WOMEN'S STORIES OF SURVIVAL**
**AND RESISTANCE**
*by Beverly Bell*
Indigenous women (farmers, market women, labor
organizers, nurses, and others) speak about their lives,
about alleviating poverty, food, housing, education, and
gender equity as inseparable from economic justice.

**WHEN THE HANDS ARE MANY:**
**COMMUNITY ORGANIZATION AND SOCIAL**
**CHANGE IN RURAL HAITI**
*by Jennie M. Smith*
Illustrates the philosophies, styles, and structures of
social organization in rural Haiti with narrative portraits
of peasant organizations engaged in agricultural work
parties, business meetings, religious ceremonies, social
service projects, song sessions, and other activities.

**WHY THE COCKS FIGHT:**
**DOMINICANS, HAITIANS AND THE STRUGGLE**
**FOR HISPANIOLA**
*by Michele Wucker*
An American journalist reports on the complex
relations between these two cultures, shedding light
on the sources of islanders' struggles both in their
island home and in the U.S.

# Acknowledgments

am grateful to my family, friends, and colleagues for their abundance of love and support. These photographs and this book are possible due to the contributions you have given to this project. Thank you, thank you, thank you.

My first trip to Haiti with *Le Sét Collective* created the "Hey You!" project and was pivotal in the making of this book. For this I am infinitely thankful to our team: Kareem Black, Craig Duffney, Jeremy Carroll, Eugene Fuller, Adam Reeves, Alessandro Simonetti, the BBDO Agency, Jeffrey Pacek, Healing Haiti, Print for Change, Wilson Jean, Jean Lisame, and Fanfan Larame. I also thank Ann D. Davidson and *Redbook* magazine for facilitating my second trip to Haiti, which allowed me to complete this personal project.

To Edwidge Danticat, my sincere appreciation for your imagination and your wonderful words.

Thank you to Umbrage Editions, especially Nan Richardson, publisher, for believing in this project and diligently working to make it come to life with such energy and commitment. Thank you to the entire Umbrage team: Unha Kim and Anja Geis, designers; Antonia Blair and Daniel Wilson, editors; and Anica Archip, publicity.

Grateful thanks for boundless wisdom and encouragement from Anya Ayoung-Chee, Alexa Becker, Fotofest, Anne Tucker, Darius Himes, Denise Wolff, John Bennette, Mary Virginia Swanson, Hank Willis Thomas, Dallin Anderson, Mary Jensen, Jacques-Philippe Piverger, Kevin Longino, Impact Trainings, Will Steacy, Lesly Zamor, Karen Fowler, Lauren Williams, Kip Kaller, Randy Granger, Mark Jenkinson, Thomas Drysdale, Deborah Willis, Wendy Evans Joseph, James Trulove, Bobbie Foshay, Beth Schiffer Lab, Teri Johnson, Naima Penniman, Aisha Bain, and Julie Santos.

To my family, thank you for always believing in me and in my work (and for not freaking out when I tell you where I'm going to photograph). My dad, John Andrew Gallery, my mom, Leslie Gallery Dilworth, my brother, Andrew Gallery, and my stepfather, Richardson Dilworth. Rest in peace Mom-Mom and Pop-Pop, and Wilbur Hobbs.

To Sean Penn, my deepest appreciation for your support of this book, and the love you have shown to Haiti.

To the book's financial supporters, your generosity was felt much deeper than your donation. You gave me daily courage and inspired me to keep going.

*Illustrious Supporters*
Patrick Gallagher, Sara Morgan, Joan Morgenstern, Hank Willis Thomas, and Gotham Imaging.

*Distinguished Supporters*
Brook Bennett, John Bennette, Steve Baroch, Adler Bernard, Rhea Castro, Yaya Da Costa, Fuse The Agency, Michelle and Michael Foster, Island People Mas, James Geitgey, Derek Jokelson, Neil Jokelson, Othni Lathram, Kevin Longino, Amy Lukas, Lana Parrilla, Santigold, Spur Productions, Laura Torgerson, Edward Yaeger.

*Notable Supporters*
Guy Abramovitz, Fernando Aguilera, Kenny Alsenat, Michelle Barnes, Adler Bernard, Erica Blumfield, Fabian Goncalves Borreaga, Nina Buesing, Adam Cabezas, Joel Cassagnol, Jerome Cloud, Nicole Dash, Deyanira Del Rio, Alexanda Diracles, Karen Fowler, Heather Gallery, Yara Garcia, Gemith Gemparo, Yo-Lynn Hagood, Dayo and Patti Harewood, Holly and Mike Hargraves, Alicia Crix Hendrie, Joanna T. Hurley, Kathy James, Alexis Johnson, Jefferson Joseph, Janet Kollock, Jenieve Langdon, Christina Lewis, Darnele Liautaud, Melissa Libertelli, Valisia Little, Jamey Lord, Christina McAdams, Mike McCauley, Melford Mcrae, Sean Meenan, Elsa Mehary, Meiling, Dougie Miller, Eileen Miller, Shannon Miller, Bianca Mills, Gina Ottley, Allyson Pimentel, Michael Pozner, Kern Ramsammy, Peter Randall, Christopher Rauschenberg, Michael Regan, Nathan Richter, Jessica Robinson, Karen Slater, Taigi Smith, Cecile Solkan, Robert Solomon, Cynthia Souccar, Karina Souccar, Rea Walton, Lia Washington, Anoma Whittaker, Mathew Yohannan.

*Le Sét Collective* (Wyatt Gallery lower right) and Healing Haiti with Children of Yvonne's Orphanage

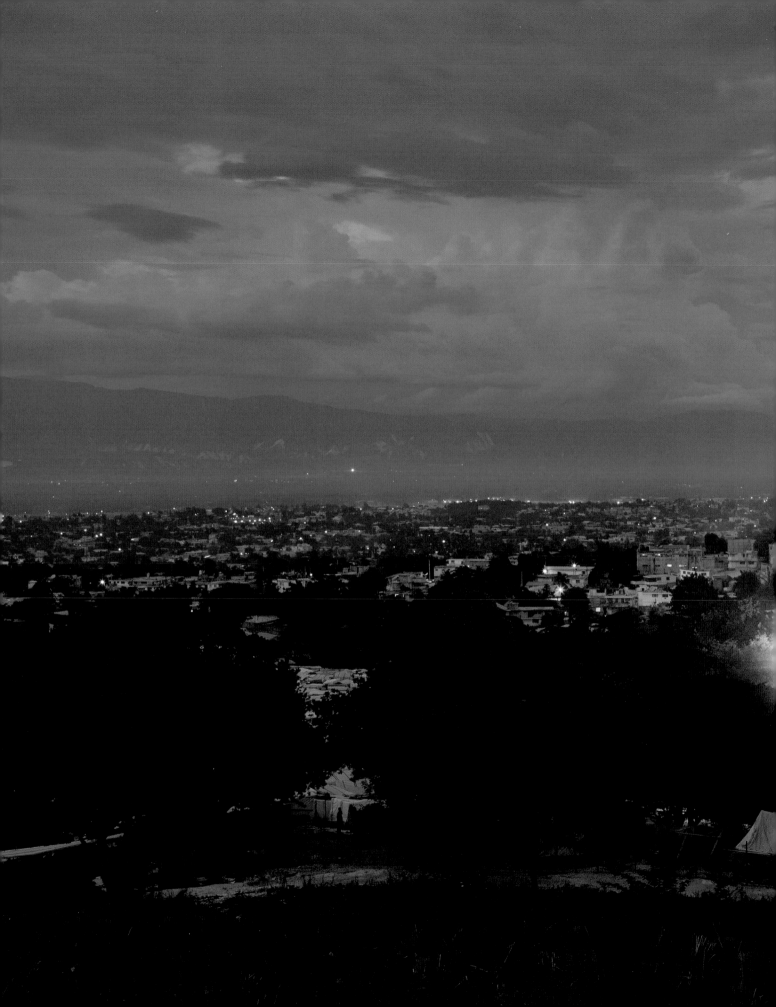

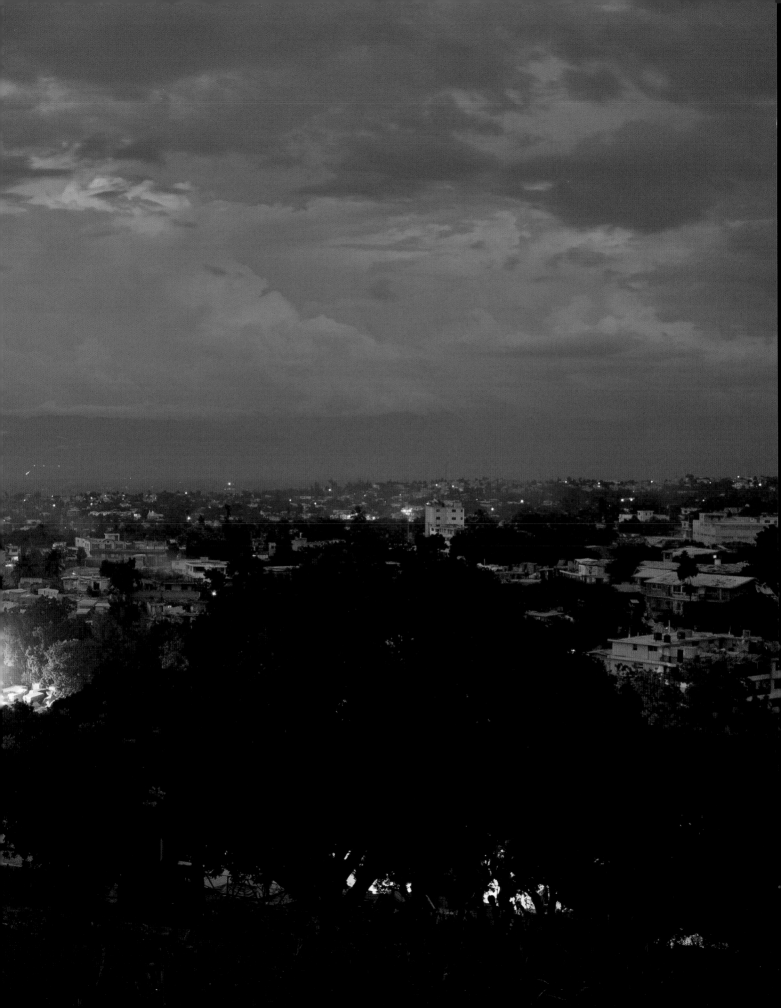

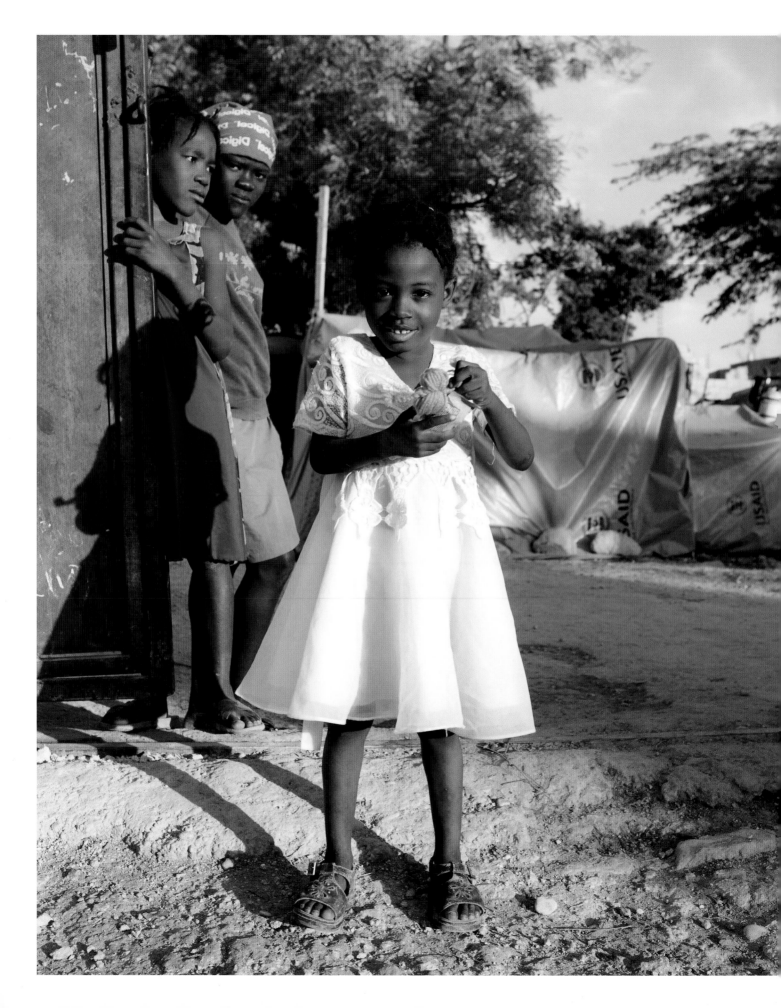

**Tent Life: Haiti**
**An Umbrage Editions Book**
Tent Life: Haiti © 2010 Umbrage Editions
Photographs and Journal © 2010 Wyatt Gallery
Essay © 2010 Edwidge Danticat
First Edition
10 9 8 7 6 5 4 3 2 1
ISBN 978-1-884167-47-8

Umbrage Editions, Inc.
111 Front Street, Suite 208
Brooklyn, New York 11201
www.umbragebooks.com

Publisher: Nan Richardson
Associate Editor: Antonia Blair
Office Manager: Valerie Burgio
Design: Anya Ayoung-Chee, Unha Kim, Tanja Geis
Editorial Assistant: Daniel Wilson

Distributed by:
Consortium (United States)
www.cbsd.com
Turnaround (Europe)
www.turnaround-uk.com

To view more photographs from this project:
www.tentlifehaiti.com / www.wyattgallery.com

Umbrage would like to thank Sidney Kimmel for his generous support.

Printed in Iceland by ODDI

Security Floodlight , Pétionville Camp (previous page)

Sunday Best, Delmas 31

GADE MWE

Y

PASE LI V

JOU

SE PA JO

"Fèy" meaning "faith," or also "leaf," became a theme song for the a voodoo *rasin* (or roots) band formed in 1990 known as RAM, who first performed it at the 1992 Port-au-Prince Carni
and though the military censored it, performed it during weekly concerts at the famed Hotel Olaffson. Their recording was widely played on the radio and immediately taken up through
the country as an unofficial anthem of opposition to the dictatorship. Printed in the liner notes of RAM's first album, *Aïbobo*, the translation is by the distinguished novelist Bob Shacoch